ACKNOWLEDGEMENTS

I am grateful to all those artists who agreed to share their marketing information for this book, to my editor and publisher Constance Smith for believing in the need for this book and for working diligently with me to make sense of my writings, and finally to my family for giving me the time to work on this book.

DEDICATION

This book is dedicated to my children —Anais and Artin—the two most original, creative souls.

Jackie Abramian
2008

Table of Contents

Introduction

As a professional artist marketing your artwork, you need to understand that you are running a business. Most successful businesses conduct publicity campaigns on a regular basis. Public relations—PR—is a cost-effective way to give a business a boost. Most artists, like many other small-business owners, fail to capitalize on the power and high returns of PR. This book will help you understand what PR is about and how to use its power.

Don't mistake PR for marketing or advertising. These three aspects of business accomplish different tasks. All three work independently of each other. PR, marketing, and advertising should all be part of your promotion strategy, but they are by no means approached in the same manner.

Advertising is costly and can drain your promotion budget quickly. Many business owners think that a glossy ad in a local newspaper or magazine is all they need for their promotion strategy—this will be sufficient to capture the attention of potential customers. Not true. For one thing, advertising is not as credible—you are tooting your own horn. Research has shown that the consumer has to be exposed to the same message at least 20 times before taking notice. That means that the cost of your ad times 20 *may* equal some attention that *may* lead to profit.

Marketing, on the other hand, is a long-term campaign carried out over many years. Marketing experts work to change public perceptions through dissemination of information that, on a long-term basis, can shift public opinion on a particular topic, like the hazards of smoking or drinking.

PR turns out to be the most cost-effective of the three methods of promotion. PR:

▸ Establishes consumer preference; a positive review of your exhibit draws consumer attention much more than an ad.

▸ Increases media awareness and visibility of a business

▸ Is credible, since it uses third-party (media) endorsement

▸ Is free

▸ Receives much more space—a full-page article, a review of an exhibition, an interview on television or radio—than advertising

Translate PR coverage into ad space and you will see how PR is the most cost-effective channel.

Power Up with PR is written to provide artists, galleries and other art world professionals with valuable tips on how to develop a PR campaign, how to utilize PR strategically to increase media visibility, and, ultimately, how to increase art sales.

So let's power up your creative business with PR!

Chapter 1

Art, Artists and the Media

Art critics

The PR practitioner

Benefits of PR

Making money is art, and working is art, and good business is
the best art.
Andy Warhol

ART CRITICS

Throughout history, the media has played a major role in shaping public awareness about the arts and artists. Often, early commentators writing in newspapers about the arts were themselves artists or scholars of art history. They were not graduates of journalism schools.

In the past, artists held intellectual discussions about the arts, about new styles and forms. They frequented, as art reviewers do today, galleries, museums, and artist studios in search of new topics or artists to write about. Their essays and art critiques raised public awareness of artistic styles in an informative and thought-provoking manner.

- Roger Eliot Fry (1866-1934), an English artist and member of the Bloomsbury Group, was a scholar of the old masters who later became an art critic. He coined the label "post-impressionism" when writing about the French painters. He is said to be the first figure to raise public awareness of modern art in Britain. The art historian, Kenneth Clark, referred to Fry as the "greatest influence on taste since Ruskin" (an American art and social critic).

- Guillaume Apollinaire (1880-1918), the Frenchman who coined the word "surrealism," was another powerful art critic.

- The American art critic Harold Rosenberg's description of "Action Painting" was later known as abstract expressionism.

Today, public perception of the arts and artists continues to be shaped by the media through art reviews, essays, videos and commentaries. Doubtless, artists are aware of the power of the media in shaping and persuading public opinion and must learn how to use this media power to their own advantage.

Your ultimate goal for public relations is to increase awareness of your art in your buying public.

What is printed or aired in the media is most often brought to our attention by PR practitioners. PR practitioners or agents design and deliver unique angles to "hook" the media into covering a particular business activity.

To bring media attention to your art, you will first need to develop the basic PR tools discussed in Chapter 2. Working as your own PR agent, you then must learn how best to utilize these tools to attract the attention of media, who in turn capture their audience's attention with news about your art.

In the following chapters, you will be given information to help you turn your creativity in the arts into creativity in PR. You will learn how to develop powerful PR tools, reach out to the media, promote and pitch your art, and place articles about your art in the various media.

The media will not reach out to you, the emerging artist. It is your job to reach out to the media and introduce your art, your philosophy and the powerful message you want to convey.

THE PR PRACTITIONER

A PR practitioner is a person who attempts to get press coverage for a business. As an artist, you will most likely be your own PR practitioner or agent.

BENEFITS OF PR

Though PR often takes time to show returns, it is always a better payoff than an ad, no matter what business you're in. Like a recommendation from a former customer, the press will toot your horn, recommend your product—your artwork.

Even famous artists attempt to get PR. Look at Andy Warhol, the master. He was always getting free media coverage.

Robert Rauschenberg hired a PR agency when he had a retrospective at the MOMA some years ago. Even though the MOMA did a lot of advertising and got a lot of press, he knew that he could get even more press if he spent a bit of his own money.

Though you might be associated with a gallery, don't assume that they know about PR. Many do not. Many gallery owners think placing an ad in the local newspaper or tourist guide is all they need to do to attract customers. Not all galleries know that they need media coverage, nor do they know how to get it.

Most often, an artist will need to help his gallery get press. Artists should be careful, however, to not overstep their territory by "telling" the gallery how to do their promotion. Proper etiquette would be to recommend some PR ideas, as well as offer help. Leave the rest up to the gallery owner.

Chapter 2
Basic PR Tools

Effective tools

Collateral

Formatting and printing your collateral

Media kit

Packaging your media kit

Men have become the tools of their tools.
Henry David Thoreau

EFFECTIVE TOOLS

PR will allow your art to reach the public via the media—a third-party endorser.

To launch a successful PR campaign and increase your media visibility, you must develop and utilize specifically designed PR tools to reach media representatives—print editors and reporters, TV correspondents, radio producers and reporters, as well as the various Internet media. You must format these PR tools for easy access by media representatives.

Three basic items are needed to create your media tools. Create these three items with care and intention as they will be the basis of your ongoing promotion, not only to the media but to all your clients.

- Business name
- Logo
- Tag line

BUSINESS NAME

Your business name can be your actual name, or it can be a group of words related to your form of art. Some artists have names that are artsy and different. Others add "art" to their name to create their business name. Kennebunk, Maine-based artist Ann Legg uses AnnLeggArt as her business name, as well as her web site address. Check out her web site: www.annlegg.com.

Your business name should be representative of who you are. If it is not your own name, then it should be words that attract attention and make sense as to what type of art you do.

When contemplating our gallery's name, we settled for Haley Farm Gallery: The gallery is located on Haley Road, on an old dairy farm, which locals still refer to as "the farm."

Take your time when choosing your business name. Make sure you are totally happy with it. You will be using it for years to come.

LOGO

The word "logo" comes from the Greek word *logotipos*—a graphic element or icon. A logo visualizes your business name by using graphics. The graphics should relate to your business. Your logo, ultimately, will "brand" or create a visual identity for your business.

- A logo should use a font that complements your business name.
- The graphic should be simple, easy to understand and visually pleasing.
- It should fit well on all your business collateral—letterheads, business cards, return address labels, web site, and media kit folder.

▸ It should be comprehensible when reduced in size.

▸ It should use few colors.

▸ It should use graphics, not photographs.

▸ It should be clear and easy to comprehend in both color and B&W.

▸ It should be easy to recall and recognize.

Whether you design your business logo or you hire a graphic designer, you need to reflect on the final product. Play a part in the design; after all, it's your business.

All your PR tools should reflect a consistent message and image. Repeated exposure to the same image will increase recall of your business in the mind of the consumer.

TIPS

→ Always project a professional look.

→ Use your own creativity and knowledge to create your logo.

→ Hire a graphic designer to carry out your ideas; perhaps you can do a trade.

→ Avoid superlatives like "the first," "the best," "the largest," etc. These have been used and overused and are no longer credible, either to the public or the media.

→ Contacting the media prematurely, before your logo and business name are in place, will be detrimental to your PR campaign. Finish this book so you are all the wiser, then start contacting the media.

TAG LINE

A tag line is a phrase or series of words that further explain your business, beyond your logo and business name. Tag lines also help consumers remember your business or product. We have all heard tag lines in commercials and introductions to products.

WELL-KNOWN TAG LINES

▸ My favorite tagline is Star Trek's "to boldly go where no man has gone before."

▸ "Pepsi Generation" defined Pepsi as the new drink and positioned it well with its rival Coke.

Your business name and logo will be on your letterhead, business card, return address labels, web site, e-mail— everything that you use to promote your business.

Tag lines should further explain your business, clarifying the concept in people's minds.

To develop your tag line, make a list of words that best describe your art and the message you want to project.

Just a few examples of words you could include in a tag line:

Colorful	Brave	Bold	Extreme
Handmade	Glass Art	Mosaic	Pearlescent

Create your own list of words according to your medium, style, and philosophy. Combine the words in different orders, and write a list of different phrases. From this list, select a tag line that is most creative, least used, and most credible.

Colorfully Bold	Handmade Plaster	Extreme Glass	Plaster Art
Bold Glass Art	Extreme Art	Colorful Mosaic	Pearlescent Glass

TRY IT YOURSELF

Write individual words below that describe your artwork.

_____ _____ _____ _____

_____ _____ _____ _____

Now combine the above words in different ways to create a credible two-word or longer phrase.

_____ _____

_____ _____

_____ _____

_____ _____

"Mainely Global Art Gallery, Gift Shop and Meeting Place" is the tagline that further explains what Haley Farm Gallery is about. "Mainely Global" is a play on words.

In our monthly e-news distributed to gallery patrons, as well as posted on our web site, we use a secondary tagline: ". . . where everyone can find an original."

EXAMPLE OF ARTIST'S LOGO AND TAGLINE

taleen
Paintings & Art on Cards

COLLATERAL

Collateral is the material that you use in your business to reach other people: letterhead, business cards, address labels, brochures.

Once you have developed a business name, logo, and tag line, you will need to display them in a unified design on your business collateral.

LETTERHEAD AND ENVELOPES

Letterheads are used for business communications and should project a professional image. Your letterhead should include your business name, logo and tag line. Also tastefully placed on the letterhead is your business address, telephone number, URL and e-mail address. This information should be large enough to read easily.

- Print your letterhead on 20-pound paper—a bit heavier than regular paper used for copying.

- Select an appropriate type of stock or color—perhaps something a bit different.

- Pastel colors—mild and easy to read when printed on—are a better choice than bold, deep colors, which usually scream out at the reader and don't project a professional image.

LABELS

You can also print return address labels with your business name and address. In our gallery, we use address labels to label shopping bags that we give to buyers. The yellow bags with our gallery's name, address and web site address are an additional marketing tool.

BUSINESS CARDS

Your business card will, essentially, look exactly like your letterhead in just a smaller rendition.

You have three main choices for preparing the layout for your collateral.

- ‣ Use a software program on your computer.

- ‣ Use an online service.

- ‣ Hire a graphic designer.

SOFTWARE PROGRAMS

The program you use can be very basic for your needs here. If you are not familiar with the program you choose, plan to take several hours to learn how to use it. In the long run, this time will pay off well. You will use this knowledge throughout your career. One popular, easy-to-use software program is Microsoft Publisher. You can use it to develop all your collateral materials, from business cards to letterhead to invites to newsletters.

ONLINE SERVICES

There are many online services through which you can design your own collateral. You can lay out and customize your promotional materials directly from your computer, using a site's template. You don't even have to be tech savvy; all you do is "fill in the blanks." You will be able to use this first template to create business cards, letterheads, return address labels, envelopes, magnets, calendars and more!

If you decide to use an online service, set aside time to get familiar with its offerings. Focus. Review the options offered. Don't rush to select a template. Review them all. Even use their 800 number for customer service to talk to someone who can help you. Some popular online companies that you can use are www.logoyes, com, www.logoworks.com, www.logodesignworks.com, ww.vistaprint.com and www.businesslogos.com.

Online services ultimately want you to print with them, and indeed, this can be an easy way to get your collateral printed. VistaPrint business cards start at $20 for 250 and go up from there; 100 letterhead for $99; 250 for $109, etc.

HIRING A DESIGNER

Search in your local area to see if there are any arts schools or colleges that offer web site design courses. Contact the design department of the school and inquire whether any of their students offer design services. Their rates would be much less than the very experienced designer. You might even find a student who would be willing to work with you, teaching you a bit as well as helping you with fresh design ideas.

FORMATTING AND PRINTING YOUR COLLATERAL

Designers' rates vary. Budget accordingly.

Another choice would be to ask the professor teaching the course to offer a contest to his students. You choose the best design and the student gets the recognition and a monetary award. Be sure to sign an agreement with the winner as to who owns the logo copyright.

PRINTING

Should you decide to purchase your own software, take your finished design on a CD to a local printer, or perhaps Staples or Kinko's. They will use your document to print out a copy to have you approve it. Then they can reproduce it with your choice of paper. Shop around in your local area. Gather prices. Get quotes. Compare. Go with the most cost-effective and reliable service.

SAMPLE BIO

Rita Katz
12245 Leibacher Road
Norwalk, CA 93422
(818) 693 1444

UPCOMING SHOWS

2008 *My Time Is Now,* Galleria Pace, Milan, Italy, one-person show

ONE-PERSON SHOWS

2009 *Venice at Dawn,* Bianca Gallery, Milan, Italy

2005 *Please Say Yes,* Academy Museum, Saleno, California

GROUP EXHIBITIONS

2008 *Send Me More,* Studio Trisorio, Naples, Italy

2007 *FROM HERE TO THERE*, Galleria Pace, Milan, Italy

2006 *American Icons,* More Gallery, Milan, Italy

2004 Academy Museum, Saleno, California

2002 Continental Galleries, Los Angeles, California

COLLECTIONS

Academy Museum, Mylara, California

De Pasquale Collection, Milan, Italy

Various private collections in Chicago, London, Rome, Venice, Amsterdam

PUBLISHED

2008 *Arte,* October

2004 *Encyclopedia of Living Artists in America*

COMMISSIONS

2007 *Wall murals (in egg tempera),* private villas in Naples and Capri, Italy

2003 *Pair of folding screens for stage set,* Milan, Italy

MEDIA KIT

A media kit's success as a PR tool depends on its content, formatting and organization.

Adapt each media kit you send to a potential promoter to that particular person's needs. Try to be innovative and creative when developing your kit.
- Show your artwork on the cover.
- Insert a sample of your artwork—a miniature or postcard—inside the folder.
- Include something unusual; a small, inexpensive paint brush attached to your business card, which the media can keep in their pencil jar; a pop-up paper easel that can hold your business card, etc.

In the PR world, you reach the media by submitting a packet of information that tells them about your art background. This packet is known as a "media kit." Every business or organization that begins a PR campaign—planned action steps for promoting public relations—must develop a media kit. You will need a media kit in a printed format, as well as an online format for your web site (covered in Chapter 3).

PRINT FORMAT

Your media kit is the packet that will carry your information to the media. It should include:

- Bio
- Artist statement
- Samples of artwork
- News clippings
- Q&A

BIO

A biography—bio for short—includes your art-related history. Ideally it is one page, easy and quick to read. It includes:

Contact information - This information appears on your business collateral. Since it's already on your letterhead, and you will be printing your bio on your letterhead, you do not need to repeat it in the body of the bio.

Exhibitions and shows - List the most important, highly recognized exhibits by date, with the most recent listed first.

Awards and honors - List the most important awards and honors that you've received.

Memberships and professional affiliations - List the most important organizations you belong to that are related to your art.

Community affiliations - List the most important community organizations you belong to that are related to your art.

Publications - List the most highly recognized publications, including specialty magazines about your art style, that your art has been published in.

Education - Include formal artistic education as well as workshops, certificate programs, and master classes you have attended with well-known artists.

Collections and commissions - List companies and people of importance who collect your artwork.

Miscellaneous categories - If you've been an artist-in-residence, were an invited speaker, list that here.

AN EXAMPLE OF A LESS FORMAL BIO

About Michal McKeown

Michal McKeown has been creating glass art since 1981. She holds a diploma in mixed media from School of the Museum of Fine Arts (Boston), an MFA in sculpture from California State University, and a Master's in glass from University of Sunderland (UK).

Michal's numerous group and solo exhibits have included those at Museum School Gallery; OCCCA, Irvine Group; the Art Building, LA Group; DIAA, Maine Group, and, most recently in 2005, at The Biscuit Factory in Newcastle, UK. She is the 2005 winner of The Kiln Care Prize for outstanding development in practice.

ARTIST STATEMENT

An artist statement is a well-thought-out, detailed essay on why you create your art and what you hope to convey to your public. This should not be more than a few paragraphs. It can be one short paragraph.

This statement plays a critical role in telling your public your philosophy as an artist. This statement is ever-changing, so don't hesitate to reconstruct it periodically.

Start to create your artist statement by writing about your art and why you create it—what you do. Take each sentence and expand on it. Explain more about some aspects and cut back on others. Perhaps you are using a technique that needs to be explained to the public or media.

Read and re-read. Edit parts that are not clear. Ask a friend or a colleague to read the statement, checking for clarity. Revise your statement and keep adding and editing until you feel comfortable with it. Remember, you don't have to create a long statement. Whatever your final version, it should be written clearly and should fully define your artwork. No fancy words.

If you are not a good writer or have difficulty articulating your art into words, seek professional help. It is worth the investment. Ask:

▸ A friend who has writing capabilities

▸ An English teacher at a local school or college

▸ An editor at a local newspaper or magazine

Your artist statement is printed on your letterhead.

See page 118 of *Art Marketing 101, 3rd Edition* for more information on creating an effective artist statement.

▸ Hire Erica Jeffrey at e.jeffrey@comcast.net. She has been proofing and editing ArtNetwork's books for years.

▸ Try posting a listing on craigslist.com for a designer noting your budget restraints.

Look at New Hampshire-based artist Lisa Reinke's statement. I have used parts of it for the two solo shows we've done for her at our gallery. We included the full statement in her artist's book—a binder that Haley Gallery offers visitors, which includes artists' resumes and statements. We used *Renew All Things Human* as the title of one of her solo shows. The second example by Rhode Island-based artist Taleen Batalian is quite different, yet quite effective as well.

RENEW ALL THINGS HUMAN

The human face inspires me. As humans, we respond to its image beyond all others. For all its familiarity, we rarely pause to consider the face as a visual form, something more than the recognition of a friend or an interaction with a stranger. I paint the face in ways to cause the viewer to reconsider its splendor and renew faith in all things human. You will recognize yourself, someone, everyone and no one in my faces.
I create fun, vibrantly colored figurative and portrait paintings in oils.
Celebrate color in the shape of a nose, the curve of the ears, the mask of the eyes, and the lines of the lips and hair. Most of all, remember the humanity in humanity.

Lisa Reinke

For years I have been fascinated with the myriad of things I could do with the surface of my paintings. Perhaps it was this, which lead me to explore encaustic painting.
Here, I could satisfy the 'surface thing' with the richness of beeswax, then go further, with form, line, space and light.
This work is a combination of oil paint, both in, and on, beeswax.

Taleen Batalian

SAMPLE LAYOUT FOR ARTWORK

Oceanic, oil on canvas, 43x84"
2007. $3550.

Conjuring Beauty, stitched textile, 46x43."
2007. $5000.

Venu Gita, oil on canvas, 30x30"
2007. $1750.

Women in the Wine Mist, acrylic on canvas, 40x30"
2008. $2250.

SAMPLES OF ARTWORK

To project a professional look, you should hire an experienced photographer to create digital images of your work. These images can be used on your web site as part of your gallery (discussed in Chapter 3) as well as in your print-format media kit.

Your photographer should be able to provide you with high-resolution copies of your images.

▸ The media will need high-resolution images at 300dpi (dots per inch). These are called "tifs" and reproduce well when printed.

▸ When uploading to the Internet, you will use low-resolution images ("jpgs") at 72dpi.

For your print-format media kit, sample works can be printed out from your office ink jet printer.

▸ Be sure to align them well if you have more than one work on a page.

▸ Images should be printed in color if your work is in color, and in black and white if your work is in black and white.

Slides and photographs are almost extinct. You can take your slides or photographs to a print shop such as Kinko's and they will convert them into digital format for you.

▸ Request a tif format at 300dpi in "CYMK."

▸ Request a jpg format at 72dpi in "RGB."

An optional medium for sharing your artworks is on a CD, which would include:

▸ A cover design with your name, contact information, logo

▸ Samples (10-20) organized by category and/or date of creation

▸ Images in jpg format, for fast and easy viewing

▸ Titles for each work, as well as retail prices, size, medium, etc.

NEWS CLIPPINGS

As you begin to receive media coverage, keep your "clippings"—the published articles from newspapers and magazines—in a clipping book. Photocopy these articles. Include the name of the publication and the date it was published. Include these copies in your media kit. If you have many clippings, select no more than five pages of the most highly recognized media outlets.

Even if you send a CD, you should still include printouts of your artwork in your media kit. It is the most convenient way for an editor to view your art.

ART

A view of Haley Farm Gallery shows several portraits by Lisa Reinke.

ART REVIEW by Ann Bryant

Happy birthday

Artist gives gifts during her 40th year

If Lisa Reinke's 40th birthday was a bull, she's got it by the horns. Her recent works and a few from the past couple of years are hanging right now at Haley Farm Gallery. In a way, if attention is paid to the timelines of when paintings were created, "Face to Face" is a retrospective from a few examples from as far back as 2003 to as recent as this November.

Reinke's work is probably known best by its daring use of color and her thoughtful approach to portraiture. Earlier works from 2003 to 2005 show an adherence to realism and reliance on details. The subjects' faces fill the canvasses in nearly all of her work, drawing attention to brightly colored features. Pieces like "Day with Friends," done in 2004, starkly contrast her most recent work which in many ways is more interesting and refined.

The earlier style harkens back to Andy Warhol pop art fantasy, where the light on someone's blue cheek shows an orange glow, and strands of hair are hot pink. Very few pieces are monochromatic and none of them are repeated in different color schemes.

At times she excels at translating emotion and personality, like with "Mandala," a piece that hangs in the back of the gallery and grabs your attention for its size and honesty. Other times she draws your attention to the balance of the piece itself and to composition like with "Vlad," a portrait of the upper left quadrant of a man's face, where his eye stares unfocused into the room.

There were only a few paintings from the past couple of years where her methods aren't as satisfying. "In Bloom" looks less like a face and unfortunately your eyes are drawn not to a cheek, but to a block of two-dimensional pink. Next to a gem like "Sprite," a nearly monochromatic blue study of a young girl with a braid held by a maroon elastic, it lacks the attention and care that most of her pieces have. Near the

WHAT FACE TO FACE, solo exhibit by Lisa Reinke
WHEN through Dec. 23. On Dec. 16, 3-5 p.m., Lisa Reinke will hold an open studio at the gallery. The public is invited to join her as she creates one of her portraits in an afternoon of open studio painting.
WHERE Haley Farm Gallery, 178 Haley Road, Kittery, Maine
CONTACT (207) 439-2669, www.haleygallery.com.

edges, random brush strokes might add texture but they don't add to the overall composition.

She's come full circle, though, when you see "Rock 'Em" and "Sock 'Em" hanging one over the other. The eyes are apparent in these more recent pieces, but the hints at heading for the abstract finally come to fruition here in a fully explored and satisfyingly executed way. They would be effective individually, something that's truly special for pairs and tryptichs.

Reinke's the one giving gifts for her birthday. For 40 days, the prices on every one of these paintings are discounted by $40. There are also bins marked "Take me home- Art good to go," for those who might want to carry out a piece of art for taking home right away. They are reasonably priced, as well.

As far as the holidays are concerned, Haley Farm is packed with great handcrafts like jewelry and handmade cards. It's a gallery run by friendly people with big hearts, who have created a place that's fun to visit.

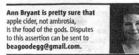

Ann Bryant is pretty sure that apple cider, not ambrosia, is the food of the gods. Disputes to this assertion can be sent to **beagoodegg@gmail.com.**

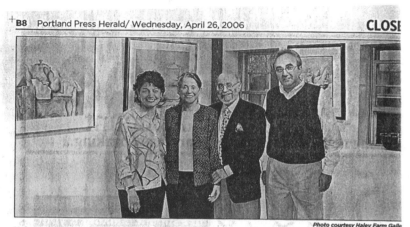

B8 Portland Press Herald/ Wednesday, April 26, 2006

CLOSE

Photo courtesy Haley Farm Galle

Haley Farm Gallery owners Jackie Abramian, far left, and Harout DerSimonian, far right, pose with artist Samuel Bak, second from right, and his wife, Josee Bak. Examples of Bak's work are displayed in the background. Bak, 73, is a Holocaust survivor whose work depicts scenes from childhood memories of brokenness.

Show at Kittery art gallery honors victims of genocides

The four featured artists are survivors or descendants of the Jewish Holocaust and Armenian Genocide.

By DEBORAH SAYER
News Assistant

They were two distinct people groups who experienced similar, unimaginable atrocities: the near annihilation of their kin. Survivors and descendents of the Armenian Genocide (1915-23) and the Jewish Holocaust (1933-45) have come together to pay tribute to the memory of their lost loved ones with a group exhibit, "Art of Remembrance."

The exhibit, part purging and part healing, is on display through May 20 at Haley Farm Gallery in Kittery. It features the works of painters Ross Saryan, Sandra Jeknavorian and Samuel Bak and photographer Hakob Hovhannisyan.

Gallery owner Jackie Abramian said that artworks represented in the exhibit include oil, watercolor and mixed media paintings, as well as photographs of the Armenian countryside. All are available for purchase.

The gallery offered similar subject matter during last year's exhibits, though this display features the works of a younger gen-

work. For the past six decades he's used mixed medium to depict scenes of destruction and brokenness based on his childhood experiences in the Holocaust.

Examples of his work include paintings of a broken tea service on a table; images Abramian said serve to capture the reality that normal Jewish life was abruptly interrupted with horrifying effect. The theme behind much of Bak's artwork lies in the Hebrew word "tikkun," meaning to have been

ABOUT THE EXHIBIT

"ART OF REMEMBRANCE," commemorating the Armenian and Jewish holocausts, runs through May 20 at Haley Farm Gallery. The gallery will host a "Literature of Survival" event from 3 to 5 p.m. Saturday – an afternoon of verse and music featuring poets Diana Der Hovanessian and John Perrault. Folk instrumentalist Martin Harutunian, founder and director of Arev Armenian Folk Ensemble also will perform. The event is free and

destroyed or left incomplete. The group of paintings are from Pucker Gallery of Boston.

Abramian said that this group of artists "work with their heart, mind and hands to capture something others can not, citing Bak as an example.

"(The are) is so much part of his life," said Abramian. "He works daily and exhibits works worldwide. It's his mission to let people know what happened."

News Assistant Deborah Sayer can be contacted at 282-8228 or at:
dsayer@pressherald.com

28

Q&A

Another helpful tool for the media is a question and answer sheet—a Q&A. The Q&A will help the media understand your art better. For instance, Ray Bliss Rich, a Hillsboro, New Hampshire-based artist (www.sumi-art.com) explains his Sumi-e painting on his web site. His art form is not widely known in the US, and his Q&A is educational and helpful to reporters.

To design a Q&A, put yourself in a reporter's position. What would you ask the artist? What would you want to know about the art form—how it was created, why it doesn't fade? What is the process? What tools are used? How long does it take to create? How many other artists in the country create in a similar way? Draw questions from the typical queries you have already heard from your public.

List five to ten questions and provide answers in simple English—no technical jargon comprehensible only to your creative colleagues. Remember, you are not promoting your work to other artists, you are pitching the media and eventually the public. While some art critics may know your specific art form, do not expect all media representatives to be knowledgeable about art. The purpose of a Q&A is to clarify, simplify and make your art comprehensible, not to create more confusion.

Your Q&A should be printed on your letterhead and be no more than two pages in length; one is better. Focus on the most important, relevant questions and provide clear answers. Questions should be in bold type, enabling the reader to scan quickly.

Your Q&A sheet is printed on your letterhead.

Q&A

Q: How are Lightscapes Glass sculptures different from other glass sculptures?

A: My works in glass are an exploration in mould melted and hot poured glass—of the qualities or aspects that glass can be and of the specific qualities achieved through this process including translucence, transparency, mass, edge, color, movement, gesture.

During the process of the hot pour I respond to the work as it is forming by drawing into the hot glass with a steel rod. There is an inherent essence in the work . . . and when I am drawing, I am responding by thinking about this essence, which is the feeling the work is giving me as it is being formed.

My purpose is to let the essential be revealed and let the work speak for itself. My work is primarily about ideas, represented in mediums that let the idea have form and expression.

Q: Why is this technique used rather than glass blowing techniques?

A: It allows me to explore and investigate light in a way that develops my perception of what I am in relationship to the world.

Q: How does this technique make the glass sculpture different to shape, manipulate, etc.?

A: I respond to my glass art as it takes form. My work becomes an investigation to discover what is already true about movement within structure, flow within form, activity within stillness. My glass sculptures are a visually dynamic statement about the relationship that is inherent to movement within structure. Each of my glass pieces is an expression of Soul and light unbounded. I create each piece with great intentionality and Soul.

Through my glass artwork I aim to inspire, encourage questions and create a feeling of vitality, movement, freedom and the flow of life. I think about the interplay of light and color and how to express ideas in glass. What shapes my glass art on the external level is: nature, music, dance, and movement while internally it is clarity, structure, concepts of connection, community, and correlation of work itself.

Q: How do your sculptures carry a message of peace?

A: Peace takes courage; it takes focus, persistent patience and keeping the big picture in mind. Making art requires the same commitments, although the world distracts you in a multitude of ways.

In creating my glass artwork, I use the same techniques as a peace negotiator. I apply my patience, I listen, I respond in context, I keep out distraction; most of all I am persistent. Glass is a statement of strength. While the physical glass itself can break, the meaning or the feeling it inspires and message it illuminates cannot be broken.

I want to investigate ways in which glass and metal relate to bring wholeness to form and structure. People take form in relation to their environment. Those living in healthy environments adopt a robust form while those in struggling countries reflect their sorrows and heartaches.

My art aims for learning to see into and through, instead of glancing at the surface: as with glass, so with people, hence so with efforts for peace. Art raises the conscious awareness of present beauty – and there can be no anger in presence of beauty.

Once all five sections—bio, artist statement, samples of artwork, news clippings, Q&A sheet—have been created and you are satisfied with the content, print out each page on plain white paper. Review for typos, spelling errors, etc. Once all the edits are made and you are completely satisfied, compile 30 copies of each item so that you have them ready for distribution.

▸ Print the first pages of the bio, artist statement and Q&A on your letterhead. If any are two or more pages in length, print the second page on plain paper.

▸ Collate and staple sections that are more than one page in length.

Once you have printed everything, you are ready to compile the five sections in a two-pocket folder.

▸ Include in the right pocket of the folder the bio, followed by the artist statement and samples of artwork.

▸ Include in the left pocket your Q&A sheet followed by news clippings.

▸ Insert a business card into the slot provided on the folder.

▸ Insert your CD in either of the pockets.

In the next chapter we will discuss how you should transfer this information to your web site's Newsroom.

PACKAGING YOUR MEDIA KIT

Q&A

NEWS CLIPPINGS

BIO

ARTIST STATEMENT

SAMPLE OF ARTWORK

BUSINESS CARD

ACTION PLAN

- ❏ Define what your business is and create a name.
- ❏ Create a logo that best visualizes your art business.
- ❏ Create a tag line that further explains and clarifies the mission of your art.
- ❏ Design your business collateral—letterheads, business cards, return address labels—to reflect a professional image.
- ❏ Print your business collateral.
- ❏ Create a bio.
- ❏ Create an artist statement.
- ❏ Create a Q&A.
- ❏ Lay out samples of your artwork on your computer.
- ❏ Organize your media kit.

RECOMMENDED READING

Marketing Kit for Dummies by Alexander Hiam

Media Kits on a Shoestring: How to Create Them without Spending a Bundle by Joan Stewart

Chapter 3

Using the Internet for PR

Creating a media-friendly web site

E-newsletters

Blogs

Going live

Put yourself on view. This brings your talents to light.
Baltasar Gracian

CREATING A MEDIA-FRIENDLY WEB SITE

Artists can maximize their visibility and reach a world audience through a web site.

In a recent survey, 1,000 journalists across the US underscored the importance of a content-rich online newsroom for businesses pitching the media.

A PDF/Portable Document Format is a computer format that saves a document in page-layout form and is readable by Acrobat Reader, a software program available free at www.adobe.com. This format is commonly used for sharing documents online.

Your web site will become a permanent exhibition gallery of your art for sale, accessible by anyone, anytime, anywhere.

YOUR ONLINE NEWSROOM

You will want to include an "Online Newsroom" link on your web site home page for the media's perusal. An Online Newsroom will turn your web site into a great PR tool. It will provide the media immediate access to your media kit and other newsworthy information.

Your Online Newsroom should include these links: In the News, Upcoming Events, Press Releases, Media Kit, Educational Materials, Testimonials. Also of interest to your clients and the media are your E-Newsletters and Blog.

In the News

In this section of your web site, include articles published about your art. List them in chronological order, most current first.

- If you have the text of the article, include a paragraph or two or the entire article.
- Provide the title of the article and direct readers to the original article via a link to the media. Note the date it was released.
- A good example of this type of link is: http://archive.seacoastonline.com/2005news/06282005/it/49894.htm.

Upcoming Events

List your exhibitions, talks, open studios here. Be sure to include dates and times. Have a "Sign up to be on our e-news list" link on this page.

Press Releases

Include a list of press releases you've created and the dates when you distributed them. Have a link to the PDF document. Visitors can then click on the title of the press release and link to the full text of the release.

- A good example of this type of link is www.lightscapesglass.com/Press-Release-2-8.pdf.

Media Kit

Turn each page of your print-format media kit pages into a PDF file and upload it under your online Media Kit.

- Bio
- Artist statement

- Samples of artwork

- News clippings

- Q&A

Educational Materials

Another online link you can use to your advantage is Educational Materials. Potential clients will love this section. Write short, concise articles on a topic that you are familiar with that will help your potential collectors understand art better: "Choosing art at an outdoor fair," "Viewing art at a museum," etc. Add articles as you get inspired.

A good example of this type of link is www.annlegg.com/g.html#6g.

Testimonials

Comments from galleries, reviewers and buyers are great for your E-newsletter. These comments can also be strategically placed in other parts of your website.

E-NEWSLETTERS

Electronic newsletters or E-newsletters are sent via e-mail. They are the most cost-effective and expedient way to reach the media and keep your public informed about your art. After you create and blast an E-newsletter to your e-mail list, post it in PDF format on your web site.

Have current and back issues of your regularly published E-newsletter accessible online. (You can also print these and include them in your print-format media kit.) Make sure there is a link on your web site for customers to sign up on your e-mail list to receive future newsletters.

Maintain a consistent design for your E-newsletter that matches your business collateral: logo, tag line, etc. Keep them newsworthy and content-rich, entertaining, and informative.

An e-mail blast or broadcast is the industry's lingo for sending one e-mail to multiple recipients.

- A masthead should be on the top portion of your E-newsletter (a masthead includes your business name, logo, date)
- Visuals
- Text
- Links to your web site pages, directing the media to your Online Newsroom with a click of the mouse.

The frequency of your E-newsletter can be monthly, bimonthly, quarterly or occasionally. Whatever frequency you decide on, maintain it. Be consistent.

INCLUDE IN YOUR E-NEWSLETTER:

- Articles to highlight your art and upcoming events
- Upcoming exhibits
- Educational information; let the media know you're an expert in a given field
- Visuals, visuals, visuals
- Contact information—make sure the media knows how to contact you by linking to your web site and e-mail address
- An opt-out or unsubscribe link must appear at the bottom of your E-newsletter. Recipients can click on this link to request to be taken off your e-mail list so they won't receive future e-mails.

PREPPING YOUR E-NEWSLETTER

While you can print hard copies of your E-newsletter and include them in your media kit, they are intended to be distributed electronically.

Before distributing:

- Print out a copy and review it for spelling, grammar, and balance of design and text. Watch for errors in design or lines that may be cut off at the edge of the page.

- Finalize the newsletter's design, format and content.

- E-mail a copy to yourself so you can see exactly how it will look when read by your e-mail recipients.

E-MAIL BLAST ETIQUETTE

Once you have refined your E-newsletter to your satisfaction, you are ready for e-mail distribution. The intent is to increase your e-mail database, which in time will become your best PR tool.

You can compile an e-mail list of:

Friends	Colleagues	Arts organizations	Galleries
Artists	Architects	Interior designers	Corporations

- For multiple recipients, use the BCC—blind carbon copy—option. This will hide the long list of e-mail addresses from other recipients.

- Use initial caps—never all caps in the subject line.

- Always put catchy words in the subject line.

UPDATE YOUR E-MAIL LIST

Use "Opt Out" requests to update your list.

EXAMPLE OF E-NEWSLETTER

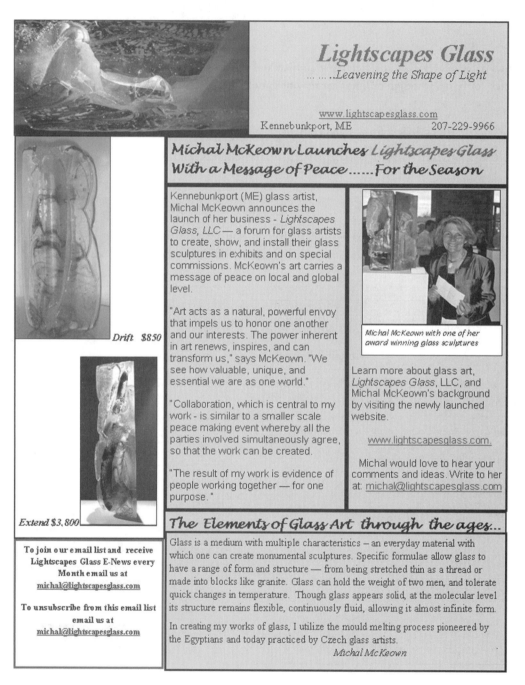

Lightscapes Glass
...Leavening the Shape of Light

www.lightscapesglass.com
Kennebunkport, ME 207-229-9966

Michal McKeown Launches Lightscapes Glass With a Message of Peace For the Season

Kennebunkport (ME) glass artist, Michal McKeown announces the launch of her business - *Lightscapes Glass, LLC* — a forum for glass artists to create, show, and install their glass sculptures in exhibits and on special commissions. McKeown's art carries a message of peace on local and global level.

"Art acts as a natural, powerful envoy that impels us to honor one another and our interests. The power inherent in art renews, inspires, and can transform us," says McKeown. "We see how valuable, unique, and essential we are as one world."

"Collaboration, which is central to my work - is similar to a smaller scale peace making event whereby all the parties involved simultaneously agree, so that the work can be created.

"The result of my work is evidence of people working together — for one purpose. "

Michal McKeown with one of her award winning glass sculptures

Learn more about glass art, *Lightscapes Glass*, LLC, and Michal McKeown's background by visiting the newly launched website.

www.lightscapesglass.com.

Michal would love to hear your comments and ideas. Write to her at: michal@lightscapesglass.com

Drift $850

Extend $3,800

The Elements of Glass Art through the ages...

Glass is a medium with multiple characteristics — an everyday material with which one can create monumental sculptures. Specific formulae allow glass to have a range of form and structure — from being stretched thin as a thread or made into blocks like granite. Glass can hold the weight of two men, and tolerate quick changes in temperature. Though glass appears solid, at the molecular level its structure remains flexible, continuously fluid, allowing it almost infinite form.

In creating my works of glass, I utilize the mould melting process pioneered by the Egyptians and today practiced by Czech glass artists.
Michal McKeown

To join our email list and receive Lightscapes Glass E-News every Month email us at
michal@lightscapesglass.com

To unsubscribe from this email list email us at
michal@lightscapesglass.com

BLOGS

The word "blog" is the combination of the words *web* and *log*. Blogs are online journals that report on a particular issue or topic. They can include visuals as well as links to other web sites.

Blogs can be a vital PR tool providing information on your artistic activities, travels, participation in shows, workshops, etc. Blogs keep the public and media hooked and informed of your artistic activities.

Blogs are gaining amazing popularity. According to blog search engine Technorati, there were 112 million blogs in 2007.

HOW TO CREATE YOUR OWN BLOG

It's easy to create a blog. You don't need to know anything technical. You can find free blog services online. www.blogsome.com is a free blog service that will lead you through easy steps to creating and uploading your own blog.

TIPS

→ Keep your blog updated.

→ Add new visuals as you create new artwork.

→ Keep your blog entries short and sweet.

→ Offer "newsworthy" information about your art.

→ Many artists sell their art directly from their blog. Original works start at postcard size up to 14x18″ and sell from $30-400.

SITES TO REVIEW

▸ paintingadayproject.blogspot.com

▸ hudsonvalleypainter.com

▸ painting.blogspot.com

▸ homepage.mac.com/lisareinke

Blogs are one of the hottest items these days driving visitors to any given site.

If you want a premium blog— visuals, videos, and other sophisticated enhancements— then it's best to pay for a blog service.

GOING LIVE

Make all this media information easily available to potential collectors as well.

Once all your Online Newsroom links—In the News, Upcoming Events, Press Releases, Media Kit, Educational Materials, Testimonials, E-Newsletters, Blog—are developed and uploaded to the Internet, conduct a thorough check for:

▸ Glitches such as pages formatted incorrectly, images that don't upload, titles or prices that are incorrect

▸ Dead links that go nowhere

▸ Grammar or spelling errors. Nothing is worse than a web site peppered with spelling errors.

Once links are checked and errors corrected, your web site is ready to "go live"—to become available for public viewing. Once it's live, you will want to alert the public and media about your site's existence. Read how to do this and more in *Internet 101 for Artists, 2nd Edition* (www.artmarketing.com).

Include your web site address in all your business collateral: press releases, E-newsletters, E-mail blasts, personal e-mails. Your e-mail "signature," which appears at the end of your e-mail, should include your web site address.

E-MAIL SIGNATURE

Email signatures are important to use so that each of your messages includes your name, business name, address, telephone, e-mail and a web site link. Most e-mail programs allow you to create a variety of signatures you can use for different purposes.

E-MAIL ETIQUETTE

Read an article on e-mail etiquette at email.about.com/od/emailnetiquette/a/cc_and_bcc.htm.

UPDATE UPDATE UPDATE

You must keep your web site updated on a regular basis with newsworthy information. Your PR campaign's success will depend on how well you update your Online Newsroom. Most media representatives use web sites to obtain additional information once they are pitched a story. If your web site contains old news, the media will assume it's the latest news. Don't build your web site and then forget about it.

My email signature:
Jackie Abramian
Haley Art Gallery
78 Haley Rd.
Kittery, ME 03904
207-439-2669
haleygallery@comcast.net
www.haleygallery.com

ONLINE NEWSROOM

In the News

 Hartford Express May 2008

 New York Times June 2007

Upcoming Events

 Calendar

Press Releases

 Season's Opening at Gallery February 2009

 Gallery Open House December 2008

Media Kit

 Bio

 Artist statement

 Samples of artwork

 News clippings

 Q&A

Educational Materials

Testimonials

E-Newsletters

 Spring 2008

 Fall 2007

Blog

ACTION LIST

- ❏ Create an Online Newsroom on your web site.
- ❏ Create a gallery of images online.
- ❏ Write educational articles.
- ❏ Create a testimonial page.
- ❏ Create PDFs of your press releases.
- ❏ Create a PDF of your print media kit.
- ❏ Start a blog with some newsworthy articles and commentaries.
- ❏ Toot your own horn and announce your accomplishments with an E-newsletter.

RECOMMENDED READING

Balanced Website Design: Optimising Aesthetics, Usability and Purpose by Dave Lawrence and Soheyla Tavakol

The Big Book of Designs for Letterheads and Websites by David Carter

Blog!! by David Kline and Dan Burstein

Internet 101 for the Fine Artist by Constance Smith and Susan F Greaves

Make Your Small Business Web Site Work: Easy Answers to Content, Navigation, and Design by John Heartfield

Uses of Blogs by Peter Lang

Web Design for Dummies by Lisa Lopuck

Web Design That Works: Secrets for Successful Web Design by Lisa Baggerman and Shayne Bowman

Chapter 4

Compiling a Media List

Finding your target market

Database software

An artist cannot fail; it is a success to be one.
Charles Horton Cooley

FINDING YOUR TARGET MARKET

News content is most often delivered through PR pitches.

Launching your PR campaign transforms you into a PR practitioner pitching the media, like a baseball player pitching a ball. When the media catches your pitch, you get published—you hit a home run. The media needs PR pitches. And PR practitioners—pitchers—need the media to carry out their PR campaign.

Knowing which media outlet to pitch will make or break your PR campaign. A PR campaign should be systematic and strategic, continuous and persistent.

- ▸ Once you pitch the media you must follow up with calls and e-mails. Following up any requests from the media promptly will differentiate you from others.

To create a home run pitch, think of unique angles and approaches you can use with the media. You are by far not the only one pitching the media. To "hook" the media, you will need to come up with creative ideas. You also need to understand how your target media works and what they need. Then you'll be a hit.

You have already developed a media kit and an Online Newsroom. Now you need to develop a media distribution strategy. Create your media distribution list as carefully as you designed your business collateral.

- ▸ Target the appropriate media outlets for your art. Don't pitch a maritime publication for your abstract art story.

- ▸ Keep adding to, researching and updating your media list.

To understand who your target market is, fill out the data on the next page.

Successful PR takes time.

MY TARGET MARKET

❏ Men ❏ Women ❏ Children ❏ All

Potential clients in order of priority: _____

What are their reasons for buying my art? _____

What organizations do they belong to? _____

What magazines do they read? _____

What newspapers do they read? _____

Specific region of the country to sell to? _____

Describe exactly what I am selling: _____

Define more specifically my target market: _____

Features of my artwork: _____

Who is my competition? _____

What can I learn from my competitors? _____

Benefits to buyer: Can I offer something more, something different, something better than my competitors? _____

Experience, authority, expertise. Why would someone trust me? _____

How will buying my artwork make the customer's life better? _____

How can people pay for their purchase (credit card, check, terms)? Will this satisfy my target market? _____

Am I able to produce enough original pieces for potential buyers in my target market? _____

Are there any legal considerations in selling my product to this (or any other) market? _____

See appendix for art-related publications.

COMPILATION STRATEGY

Define your target audience—who do you want to reach? Target the media outlets that reach your target audience.

EXPAND YOUR MARKET

- Talk at a local library, school, community center.

- Write an article: *Messages and Symbols in Abstract Art.*

- Turn yourself into an expert on the history of Impressionism.

- Educate others; talk to an artists' group, art association, local museum or college class.

- Consider regional magazines (e.g., *Portland* magazine, *Boston* magazine, *Los Angeles*, etc.)

CREATIVE PR STRATEGY

If your artwork is exhibited in Chicago and you live in New York, you need to add Chicago media outlets to your media list.

Send Chicago media outlets a press release about how a New York native (you!) is exhibiting in Chicago.

When a press release or article about you is published in a Chicago newspaper, send a copy of the clipping to your local New York media contact.

You now have national exposure! "New York artist featured in *Chicago Tribune*" will draw attention from your local media and may even land you a profile in your local arts magazine.

STUDY SPECIFIC MEDIA OUTLETS

Study magazines, newspapers, online sites, and TV shows to get to know your target media outlets before you pitch them.

Visit online versions of print publications. Sign up for a free copy; most magazines offer free copies on their web sites. Get a feel for what types of stories they cover. What angles are used to cover the arts? Are they integrated into design, home décor, corporate stories? Read the masthead—the column that lists the names of editors, writers, reporters, and contributors. Who are the reporters covering the arts or "feature" articles?

Figure out how your art fits into one of the regular columns or how you can contribute an article to one of the sections.

▸ Mainstream media outlets—weekly and daily newspapers—usually have an Arts & Entertainment section. Study it to see where you want your art to be placed.

With each new publication you discover, ask yourself, "How can I get them to cover my art?"

Establish yourself with the local and regional media before expanding to national media outlets.

PR TIP 1

A local businessman gave me a copy of *Art Business News* magazine. I subscribed to the magazine, started reading it on a regular basis and got to know their columns, sections and editorial policy. I sent the editor our gallery's press releases months in advance (magazine deadlines are three months prior to publishing).

I submitted post-exhibit photos. I pitched the editor for the Trendsetters column by submitting an attractive flyer with visuals and biographical information on three of our artists. I followed the magazine's format. Finally, the editor liked one of our artists' work and included the visuals of his artwork in the column. Twice!

The editor appreciated my complete, informative flyer. It made it easy for her to include our flyer. I had studied the column and knew what information was needed. When the editor contacted me to inform me that she was going to include one of our artists in the Trendsetters column, I took the golden opportunity to further my "media relations" (to be discussed in coming pages), chatted with her for a while and put a voice behind a name. This all took time and effort but was well worth it.

Compiling your customized media list

Most of your research can be done on the Internet. Magazines as well as local and regional Yellow Pages can also be used. While you're compiling a media list, continue to search for interior designers, corporate art consultants, or other categories of people who might be interested in buying or selling your art.

Compile your own media list using the Internet. Start with your local media outlets. Plan to expand eventually beyond your region and state.

- Find your local government's web site.

- Look in the Yellow Pages.

- Look in your local newspapers and magazines.

PR TIP 11

Our gallery is located in Kittery, Maine, a town separated by a bridge from Portsmouth, New Hampshire. Kittery is also 20 minutes away from the first northern Massachusetts town. Our gallery's media distribution strategy includes print, broadcast and online media outlets in MA, NH, and ME, for instance. Because of our proximity to all three states, the gallery news is distributed to and covered by media outlets in all three. This wide coverage allows our gallery to attract visitors from the entire seacoast region of all three states and beyond. We also list our gallery web site with visitmaine.com, the state tourism site, as well as the Kittery shopping outlet association's web site. Both of these web sites are viewed nationally and internationally, widening our reach.
In southern New Hampshire's seacoast region, Seacoast Media Group publishes six publications in southern Maine and New Hampshire. Their editorial contact information is listed at www. seacoastonline.com. On the masthead (information across the top of the page), under Contact Info, you can obtain mailing addresses, telephone numbers, and editors' names and e-mails. The page also provides circulation numbers for all six newspapers.

CREATE A MEDIA LIST

LOCAL DAILY _____

LOCAL WEEKLY _____

REGIONAL DAILY _____

REGIONAL WEEKLY _____

ART PUBLICATIONS _____

TARGET PUBLICATIONS _____

ASSOCIATION PUBLICATIONS _____

ART COUNCILS _____

TV _____

RADIO _____

CITYWIDE MAGAZINES, LOCAL _____

CITYWIDE MAGAZINES, REGIONAL _____

Go beyond the media to add names to your list

- ▸ Buyers - Always have a guest book at your art event.

- ▸ Colleagues - Get names when you attend workshops, teach a class, etc.

- ▸ Professionals - Compile a list of associations you belong to, spoke at, exhibited at, and their members.

- ▸ Friends - Your best advocates

- ▸ Referrals - Ask friends, colleagues, buyers, professionals to provide you with e-mail addresses of individuals who may be interested in your art.

- ▸ Networking - Join business groups and attend meetings in your area: Chamber of Commerce, Rotary Club, Lions Club, YMCA, etc.

- ▸ Online communities - Promote to art-related web sites. Most of these communities offer free memberships or subscriptions. Some may be worth the subscription fees as an investment in your PR campaign.

DATABASE CHOICES

Having your database easily accessible on your computer can make your promotions easy. Your computer might have a built-in program, so before you buy a new program, verify that you don't already have one. If you do need to purchase database sofware, your best bet, as a small company, would be to get Microsoft Pro. Once you compile your list, you can add names whenever you find a new contact. You will keep it current by mailing periodically to the list. This list information will be of utmost value to you, so be sure to back up the data.

Your database media list is an ever-changing document. Categories to use:

Company or organization - name of the media outlet (e.g., ABC News)

Media or organization type - magazine, weekly or daily newspaper, TV, radio, online, cable

Location - city and state

Contact - editor/reporter's name, telephone and e-mail

Beat - what topics the specific editor/reporter covers

Circulation - number of people the publication reaches

Deadlines - for articles, calendars and general copy

Notes - Make notes about your contact with the media; "contact in 2 weeks," etc. Date your notes for easy follow-up.

DATABASE SOFTWARE

ACTION PLAN

❑ Define your target media.

❑ Use the Internet to search for a listing of local and regional media outlets. List five media outlets:

_____ _____

_____ _____

❑ Create a database of all your media contacts.

❑ Update your media list periodically.

RECOMMENDED READING

Encountering the Media by Barry McLoughlin

Managing the Media: Proactive Strategy for Better Business-Press Relations by Fred J Evans

Planning Media: Strategy and Imagination by William J Donnelly

Chapter 5
Press Releases

Writing a press release

Formatting a press release

Hooking the press

PSA

Calendar listing

Media distribution strategy

True ease in writing comes from art, not chance.
Alexander Pope

WRITING A PRESS RELEASE

A press release announces a new exhibition or show, for example, and is generally one page.
A media kit contains several items, offering information on the artist, her previous work, her newest exhibit, etc.

The addition of an image, or visuals, to a press release increases its chances of being published.

Send a copy of your press release to your favorite patrons as well.

Communities are finally realizing the power of the "creative" economy, attracting artists and art appreciators to towns as a profitable win-win situation. Mill buildings across America are being renovated into artists' studios and galleries, which contribute to economic revitalization. Editors of regional print, online and broadcast media are responding by providing arts news and are therefore in dire need of this type of news.

Being equipped with PR tools before you contact the media helps expedite your PR campaign. Writing and distributing a properly formatted press release and media kit and conducting proper follow-ups with the media is the most efficient way to launch a PR campaign and communicate with the media about a newsworthy event. Combined with your media kit, your press release becomes a powerful PR tool to reach and capture media attention.

USE A PRESS RELEASE TO ANNOUNCE:

- An upcoming exhibit, event, show
- An Open Studio
- Winning a competition or receiving an award
- Obtaining an artist's residency
- Being juried into a show
- Being published in a book or magazine
- Being picked up by a gallery or museum to be part of their stable
- Giving a talk, seminar, conference
- Having artwork hung in a corporate space (hospitals, airports, bus terminals, etc.)

MAKE SURE YOUR PRESS RELEASE:

- Is timely, announcing an upcoming event
- Is newsworthy, announcing something unique, new, and captivating
- Answers the five W's: Who, What, Where, When, Why
- Explains how you were selected for a residency: competition, essay, out of how many entrants, etc.
- Includes quotes or statements for the media's use
- Includes visuals. Embed visuals within the body of the release. Note in your release that high-resolution tifs are available. Send them only when a media rep requests one.

SAMPLE FORMAT FOR PRESS RELEASE

FOR IMMEDIATE RELEASE

Contact name
Telephone number
E-mail

Headline to hook editor and public
Subhead if desired
Visual

Date and place the release is being sent from

Paragraph 1 The 5 W's

Paragraph 2 More details of importance to the public

Paragraph 3 Background info

Paragraph 4 Boiler plate (see page 58)

###

FOR IMMEDIATE RELEASE

Contact: Jackie Abramian
207/439-2669
jaassociates@comcast.net

LIGHTSCAPES GLASS PROMOTES A MESSAGE OF PEACE THROUGH EACH GLASS SCULPTURE

Maine Artist Michal McKeown Observes International UN Peace Day September 21 by

Launching Her Own Glass Art Business

Kennebunkport, ME – September 19, 2007 - In commemoration of the annual International United Nations Day of Peace, observed annually on September 21, Kennebunkport-based glass artist Michal McKeown announced the launch of her new glass art business—Lightscapes Glass (www.lightscapesglass.com), a company committed to creating a forum for glass artists to create their glass sculptures for exhibits as well as commissions, while delivering a message of peace on the local and global level.

"Just as in making peace, making art requires courage, focus, patience and keeping the big picture in mind, even though the world distracts an artist in a multitude of ways," explains glass artist Michal McKeown. "In creating my glass sculptures, I use the same techniques as a peace negotiator—patience, listening, responding in context, and keeping out distraction. Most of all I use persistence.

"I invite the viewer to learn to see into and through the glass, instead of glancing at the surface. As with glass, so with people and efforts for peace, Art raises the conscious awareness of existing, present beauty."

Works by Lightscapes Glass are available for exhibit and commissions. View glass sculptures available for purchase at www.lightscapesglass.com.

About Lightscapes Glass, LLC

Founded by Kennebunkport, ME-based glass artist Michal McKeown Lightscapes Glass (www.lightscapesglass.com) is committed to creating glass sculptures with a message of peace.

For further information on Lightscapes Glass, or to set up media interviews with artist Michal McKeown, contact JA Associates at 207/439-2669 or jaassociates@comcast.net or visit www.lightscapesglass.com.

#

FORMATTING A PRESS RELEASE

Whether sending your press release through the mail or e-mailing it, you will need to format your press release for media use. Properly formatted press releases will capture media attention and increase chances of being published.

For printed versions of your press release, use your letterhead. This will legitimize the information and look professional. If you are e-mailing your press release, copy your logo on top of your release within the body of your e-mail or create a PDF of your print version.

Parts of a press release

For Immediate Release - This tells the media that the press release can be published upon receipt. Use all caps.

Contact info - This can be to the right or left of "FOR IMMEDIATE RELEASE," double-spaced below it. Include the contact name. If a PR agency is handling your press release, list that person's contact info.

Headline - The headline—sometimes called a title—should be bold, centered two lines below the contact info, and in large type. This headline should:

▸ Be catchy

▸ Be concise

▸ Sum up the main story in a few words

Subhead - Include a secondary headline, using title capitalization, to explain the primary headline further. Double space between the primary and secondary headlines.

Visual - Insert and center your visual after the secondary headline. If the visual is an artwork, be sure to note the title (in italics), medium and full name of the artist: *Salutations*, egg tempera by Shirley Katz. Attach a jpg to your press release when e-mailing.

Dateline - Double-space after the visual and include a dateline to indicate where the press release is originating from. Include the date in bold, followed with an em dash.

First paragraph - Put the "news" in the first paragraph of your press release. Do not bury the news in the third or last paragraph. The first paragraph of your press release should include the 5 Ws and How.

Subsequent paragraphs - Include supporting information.

Two-page press release

Try to keep the press release to one page. Should you have enough pertinent information for two pages, at the end of your first page include "(more)" at the

Ask your art buyers for a short testimonial. They will actually be flattered. This type of quote could really work to your advantage.

bottom righthand corner. On the top of the second page, include the artist's name and page number—Katz, page 2.

BOILER PLATE

End your press release with a "boiler plate," similar to a byline. A boiler plate tells the media about your art business.

- ▸ Name of the business or artist
- ▸ Date founded
- ▸ Function of the business
- ▸ Contact information

#

Signal the end of your release with three # # #, centered at the bottom.

YOUR PRESS RELEASE SHOULD:

- ▸ Be no longer than one page, two at very most
- ▸ Present the facts only. Include no superlatives.
- ▸ Include a statement or a quote from the gallery, artist or buyer
- ▸ Be accurate: time, date, place, etc.
- ▸ Include contact information

WHAT NOT TO DO

Apparently, more than half of the press releases received by the media are trashed.

- ▸ They contain no "real news."
- ▸ They are not formatted correctly.
- ▸ The "news" is too hidden—not in the first paragraph.
- ▸ They are filled with unrelated information.
- ▸ Incorrect contact information is included.
- ▸ A contact person was not included; thus, questions about the event could not be answered.

Do not expect the media to use your press release in its entirety.

Beyond knowing and learning about the proper format in which to prepare your press release, you must have interesting news to convey. Think creatively, out of the box.

A creative pitch will "hook" media attention. Pitching the media to attend your art exhibit is not enough "news," not enough of a "hook." You need to have a unique idea behind your exhibit: perhaps an unusual theme, philosophy, tie-in with something happening locally, etc.

MEDIA HOOK IDEAS

▸ Donate your art to the local hospital. Try to get media coverage in the business section of your local paper.

▸ Give free lessons at your local or regional schools or community center.

▸ Give a talk at the local library about how to interpret your genre of art. Pitch a story to the local education writer who would integrate your "art into public education" story. Parents or school officials drawn to the story by an education angle will see images of your art and may be interested in bringing you to their school or library or purchasing your art.

▸ Pitch the media to do a story on you as an "Artist-in-Residence."

▸ Utilize public art program opportunities to place your art in the transportation, health care, or corporate arena.

▸ Pitch the transportation magazines, the local business editors, and even the airport magazine to do a story on your artwork as your work relates to travel.

A story in the business pages will widen your audience reach. Think of how you could convey to that editor that your exhibit is of interest to the business community. Ask yourself, "What type of art exhibit is the media interested in covering?"

HOOKING THE PRESS

CREATIVE PR STRATEGY AT WORK

Most of our gallery's exhibits are themed—designed specifically to attract (hook) media attention. In addition to the artwork, we usually enhance our exhibits with talks, performances, films and panel discussions. Our exhibit-enhancing events attract media attention and provide additional listings for our gallery in various sections of the newspapers and magazines on our media list.

For September 2006, we designed an exhibit commemorating the 5th anniversary of 9/11. "Colors of Healing" featured works by local artists, including Jean Holabird—a NY-based artist who had witnessed the attacks from her Manhattan apartment window, and an Iraqi artist, Wasua Alkabi, whose works reflected her country's demise as a result of 9/11. We added children's art created by child survivors of such traumas as the Armenian earthquake of 1988, Chernobyl in 1986, and 9/11. We invited Dr Anait Azarian and Dr Vitali Ianko, two psychotherapists from Brown University, to discuss "Surviving Trauma" a week after the exhibit's opening and to discuss the children's art therapy work they had contributed to the exhibit.

We knew we wanted to honor firefighters. We searched for firefighters from our region who had volunteered during the post-9/11 rescue. We invited Governor John Baldacci of Maine to attend our opening reception and honor the Maine firefighters with a print by one of our artists, Christine Mogan. The Governor actually attended our opening!

With our pre-show PR campaign, we hooked all three network TV stations in Maine, which provided coverage of the exhibit and the Governor's appearance and interviewed our artists and the Brown University therapists. The local arts magazine put one of our artworks on its cover for the week of the exhibit with our gallery name plastered across the cover.

We were the only gallery in New England's seacoast that organized an art exhibit commemorating the fifth anniversary of 9/11. Our creative strategies turned a simple exhibit into a major news item that appeared on all the news shows in two states.

INNOVATIVE FORMAT

ArtNetwork (the publisher of this book) has been using 8.5x5.5-inch postcards (8.5x11-inch index paper stock cut in half) for their press releases for several years. When the recipient receives the press release, he doesn't have to open it to read it. It saves on envelope costs as well as stuffing costs. You can have it printed locally or print it on your office printer by printing on two sides. It will also need to be cut in half. An example follows.

PRESS RELEASE

LIGHTSCAPES GLASS PROMOTES A MESSAGE OF PEACE THROUGH EACH GLASS SCULPTURE

MAINE ARTIST MICHAL McKEOWN OBSERVES INTERNATIONAL UN PEACE DAY SEPTEMBER 21

207/439-2669

Lightscapes Glass
41Whitten Hill Rd
Kennebunkport, ME 02310

Address correction requested

MICHAL McKEOWN OBSERVES INTERNATIONAL UN PEACE DAY
SEPTEMBER 21

USE
A
VISUAL
HERE

Kennebunkport, ME – September 19, 2007 – In commemoration of the annual International United Nations Day of Peace, observed annually on September 21, Kennebunkport (ME)-based glass artist Michal McKeown announced the launch of her new glass art business—Lightscapes Glass (www.lightscapesglass.com) a company committed to creating a forum for glass artists to create and exhibit their glass sculptures for exhibits and on commission while delivering a message of peace on the local and global level.

"Just as in making Peace, making art requires courage, focus, persistent patience and keeping the big picture in mind – although the world distracts the artist in a multitude of ways," explains glass artist Michal McKeown. "In creating my glass sculptures, I use the same techniques as a peace negotiator—patience, listening, responding in context, and keeping our distraction—most of all I use persistence.

"I invite the viewer to learn to see into and through the glass, instead of glancing at the surface. As with glass, so with people and efforts for peace. Art raises the conscious awareness of existing, present beauty."

Works by Lightscapes Glass are available for exhibit and can be commissioned by private or commercial entities. To view glass sculptures available for purchase, visit www.lightscapesglass.com.

About Lightscapes Glass, LLC Founded by Kennebunkport, ME-based glass artist Michal McKeown, Lightscapes Glass (www.lightscapesglass.com) is committed to creating glass sculptures with a message of peace for exhibits and on commission.

For further information on Lightscapes Glass, LLC or to set up media interviews with artist Michal McKeown, contact JA Associates at 207/439-2669 or jaassociates@comcast.net or visit www.lightscapesglass.com.

#

PSAs

PSAs are distributed to general managers of radio stations or community news departments in TV stations to get listed on community calendars.

A Public Service Announcement—PSA—is a shorter version of a press release distributed to TV and radio stations.

▸ Broadcast media, especially radio stations, give priority to PSAs from non-profit or community-based organizations.

▸ As an artist, your PSA should promote your events as "free and open to the public." This will qualify you for inclusion in the community calendars.

PSAs SHOULD:

▸ Include one-paragraph write-ups

▸ Feature five Ws and How

▸ Have contact information

▸ Include the first paragraph of your press release

▸ Be printed on your letterhead or e-mailed with your logo

SAMPLE PSA

Lightscapes Glass
41 Whitten Hill Rd, Kennebunkport, ME
www.lightscapesglass.com

Leavening the Shape of Light

PSA

In commemoration of the annual International United Nations Day of Peace, on September 21, Kennebunkport-based glass artist Michal McKeown announced the launch of her new glass art business—Lightscapes Glass (www.lightscapesglass.com), committed to creating a forum for glass artists to create and exhibit their glass sculptures for exhibits and on commission while delivering a message of peace on the local and global level.

For further information on Lightscapes Glass or to set up media interviews with artist Michal McKeown, contact JA Associates at 207-439-2669, jaassociates@comcast.net or visit www.lightscapesglass.com.

###

CALENDAR LISTING

A calendar listing is the same as a community calendar, which appears in the events section of newspapers and includes infomation on upcoming events.

Use your PSA paragraph to help you create your calendar listing. Most newspapers will include this information in the community calendar pages. Larger newspapers give priority to non-profit organizations when selecting events for their calendar section. Free events open to the public usually qualify. Send calendar listings to the Calendar Editor at a publication.

- Create a one-paragraph write-up.

- Include all 5 Ws and How.

- Include contact information.

- Print your calendar listing on your letterhead or e-mail it with your logo in the body of the e-mail.

SAMPLE CALENDAR LISTING

Haley Art Gallery (www.haleygallery.com)
Art & Décor exhibit featuring original artwork, home décor, functional pottery and sculptures with an artists' opening reception on Saturday, April 5, 5-7pm. The exhibit will remain on view until June 13, 2008. Interior designers, architects, and residential/commercial decorators enjoy a 10% discount on purchases on the opening day. Special discounts offered on color consulting services by gallery artist and Boston-based color consultant Verjik Martin of VDesign.
Featured artists include: Austill, Brockelman, Hollingworth, Payne Sylvester, McCartin, McKeown, Finnegan-Topitzer, S Tubby, K Woodward and Verjik of VDesign. Haley Art Gallery, 178 Haley Road in Kittery, ME off of Rt. 1 at the outlets. 207-439-2669, haleygallery@comcast. net, or www.haleygallery.com.

#

Okay, so you've compiled your media list and written your first press release. Now you need to send it out. Use pre-printed envelopes (printed at the same time you printed your letterhead) or create a 5.5x8.5″ postcard-style press release like the example shown on page 61.

If you decide to mail your press release rather than e-mail it, print it on your letterhead, use your pre-printed envelopes and handwrite or print out a label with the recipient's address.

Each media outlet will have a different deadline. Be sure you follow the general rules of deadlines listed below.

- Daily and weekly newspapers: Distribute the press release two weeks prior to an event.

- Larger events: Distribute the press release three weeks prior to the event, and then again two weeks prior.

- Monthly publications: Distribute the press release three months prior to the event.

- Online magazines (e-zines): Distribute your release when ready. Most update their sites regularly.

E-MAILING YOUR PRESS RELEASE

- Paste the entire press release into the body of your e-mail or send it as a PDF attachment.

- Delete 'More' at the end of the first page, i.e., make it into a one-page document.

- Insert visuals into the body of your release. Also send a jpg attachment with the release or note that you have jpgs available.

- Use the BCC option (as discussed on page 37) if you are sending it to multiple recipients.

- Don't BCC more than 20 recipients per blast. Most Internet providers block outgoing e-mails with more than 20 recipients.

- Reply to e-mail inquiries from the media immediately.

- Have a 300dpi image—a tif file—ready to e-mail when media outlets request it.

MEDIA DISTRIBUTION STRATEGY

Print your press release on your letterhead (second page on plain paper). Check it for accuracy, grammar and spelling.

Always include captions with visuals.

THE WEEK OF YOUR EVENT:

▸ Contact the media via phone or e-mail to follow up and confirm that they have received your press release. Inquire if they'll be using it in the coming week.

▸ Keep an eye out for any coverage you may receive.

▸ Purchase newspapers or magazines featuring your press release. Make copies of all your published articles for your clipping book.

▸ Research online links to any print coverage you receive to see if the publication or broadcast media has an online version. Should you receive online promotion, include the link in your Online Newsroom's In The News section and your E-Newsletter.

❏ Format a press release for the media.

❏ Create a catchy headline and sub-headline for your press release as a hook.

❏ Use the first paragraph of your release to create a PSA.

❏ Create a calendar listing from your PSA.

❏ Note on your calendar deadlines for sending out press releases.

❏ E-mail your press release to multiple media reps. Follow up with e-mails or phone calls to confirm that they received it.

❏ Invite the media to an event.

ACTION PLAN

RECOMMENDED READING

An Editor's Guide to Perfect Press Releases by Penny Fletcher

Creating a Press Release: Writing and Submission Tips by Michael Bloch

Writing a Press Release: How to Get the Right Kind of Publicity and News Coverage by Peter Bartram

Writing Effective News Releases by Catherine V McIntyre

Chapter 6
Courting the Media

Creative media relations

Post-coverage etiquette

I throw a spear into the darkness. That is intuition. Then I must send an army into the darkness to find the spear. That is intellect. Ingmar Bergman

CREATIVE MEDIA RELATIONS

Consider media relations a courtship, a relationship-building proposition that is achieved over time, similar to building a friendship.

Media relations is establishing relations with members of the media. Keeping in continuous contact with them, creating a trust for passing newsworthy information suitable and fitting for their editorial needs will enable you to have continual coverage over the years.

The media needs press releases to generate stories as much as press releases need the media. The relationship between the PR practitioners—you!—and the media is a love-hate relationship. Editors love it when you have an article on a hot topic they need, but hate it when they are pestered about something they don't need.

Relations with the media must be conducted on a systematic basis. With some media contacts, you may follow up for weeks and months before your efforts result in an article or coverage. PR takes time. Don't be disheartened. Don't give up.

On a daily basis, newspapers, radio and TV stations are bombarded with thousands of media kits and press releases competing for attention. Your relationship to any given media representative can make or break your possibilities of publicity. You must stand out among all the others trying to vie for attention.

COLD-CALLING A MEDIA REP

Your first call to a media rep is generally the most uncomfortable. In time, practice will make perfect and relieve that first-call tension. The more calls you make to media reps—writers and editors—the smoother you will be in presenting your art business. Practice. Don't be intimidated. Reporters and editors are people just like you. They need and want to hear what's new. They want to ask questions. They want you to help them write a story. Don't create your web site, media kit, and PR tools to stay timid and shy away from the media. Push your newsworthy information to the media.

▶ Designate a day of the week to conduct your media relations.

▶ Designate one hour each day if you want to be aggressive.

▶ Make your calls when you feel good and cheerful.

▶ If you had a bad day, don't get on the phone. You'll be more negative than constructive.

▶ While you are creating your art, think of ways to push news about your art to the media.

▶ Don't just assume that the media will come to your exhibit because you invited them. You need to pick up the phone and call them to make the invitation more personal, or you could also send an e-mail and offer to meet them at the gallery prior to the opening to provide comments on the artwork. Be flexible. Meet their schedule. It will make a difference to the reporter; she will remember you.

Let the media know you are there to help them. Develop trust: Say and do! Be reliable. Make the media's job easier. When the media requests something, be prompt in helping them.

CONTACTING THE MEDIA

▶ Write out your phone pitch, refine it, and practice it a few times before you call.

▶ Turn the first paragraph of your press release into your media pitch.

▶ Put a copy of your pitch in front of you when talking on the phone.

▶ Don't sound like a telemarketer reading a script.

To have a captive audience, call the media during "down time"—when they are not under a deadline.

▶ Weekly newspapers put the paper to bed on Monday or Tuesday morning. It is not a good idea to call the editor or reporters during this time. They are rushing to meet deadlines, finish or edit articles with little time to listen to a pitch.

▶ Daily newspapers usually have morning deadlines. It is not a good idea to bother them during early morning hours.

▶ Monthly publications usually work three to four months ahead.

▶ Online publications can usually be pitched any time via e-mail.

The hook or headline often uses words cleverly, sometimes connecting to a current event. Examples: Do a play on words such as "Give Art A Chance." Use anniversaries or national commemorations to make more sense of your art or exhibit, for example, an all women's exhibit to commemorate International Women's Day (March 8).

SAMPLE PHONE PITCH

Hi, I'm (your name). I'm calling to follow up on the press release I sent you on my exhibit at XYZ Gallery on (date) and (time).
Pause. Allow the media contact to talk and ask questions. They would probably say "Yes, I remember the release," or "I have no idea what you are talking about."
If they are not familiar with your press release:
Repeat the above paragraph and offer to resend the release in an e-mail, or suggest to them that it is on your web site. Spell out the web link. Repeat it. E-mail it too.
If they have the release:
"Oh, great, so you received my press release. I hope you are planning to attend the exhibit since it commemorates International Women's Day."
Take a break and let them ask questions or reflect on what you offered. Answer their questions and offer them additional information if they are interested:
"I'll be happy to meet with you to further discuss my work and the exhibit."

Work as a team with your media contacts. They depend on you for news and information.

If the media is not interested, thank them for their time and hang up. Don't push. Don't act as though they don't know what they're missing. You can gently ask why they are not interested in the story. But that's about all you can or should say.

If the media is interested, take a breath and ask them if they need additional information: Would they like to set up an interview? Do they need a 300dpi image? Be available, responsive and courteous. Be mindful of the time on the phone. Keep your sentences short and sweet. Promptly do anything they request. Send the information while it is still fresh in their mind. Ask about their deadline. Help them meet their deadline, and they will remember you and be appreciative.

At the end of your conversation with the media, thank them for their time. "I look forward to seeing the article in print," or "I look forward to meeting you at the exhibit. Please let me know if you need any other information."

E-MAILING THE MEDIA

- ▶ Paste your written pitch into the body of your e-mail.

- ▶ The subject line should include the press release headline.

- ▶ Include the media contact's full name unless you know him personally.

- ▶ Don't include attachments.

- ▶ Send personal e-mails to media contacts when following up on a release (i.e., not in groups of 20).

- ▶ Keep your e-mails short.

- ▶ Include a link to your web site.

- ▶ Include full contact information.

- ▶ Do not follow up with the media more than once a week. Be persistent without being a pest.

- ▶ Respect media deadlines.

You are the media's source of news: Empower yourself with this thought.

SAMPLE E-MAIL PITCH TO PRESS

Dear _____,

I'm following up on the press release I sent you on my upcoming exhibition at Maxim Art Gallery (www.maximgallery.com) on Friday, March 16, 5-7 pm. I hope you'll be interested in attending the opening and in finding out more about the campaign to foster greater public support for the arts.

Please let me know if you would like a jpg of any of my artworks that will be on exhibit.

I look forward to hearing from you soon.

Artist name, address, tel #, e-mail, web site

RECORDS OF MEDIA CONTACTS

An important part of media relations is keeping good records of your discussions with each person. Keep brief notes in the notes column of your media list. If a reporter or editor suggests you "Call me in early April," don't e-mail him every week in March. It will irritate him, reflect a non-professional image, and may cost you a media placement.

POST-COVERAGE ETIQUETTE

Once an article about or mention of your exhibit is published, send the reporter a thank-you note.

- Keep your thank-you note short and sweet.

- Address the reporter/editor by first name.

- Mention the article you are talking about (they write many articles and can't remember every artist's name).

- Thank the reporter for providing you exposure.

- If your public mentioned the article, let the writer know it.

- Let her know that she contributed in some way to your sales.

- Keep the reporter's name on your media list and send future press releases with a personal note.

In time, you will establish yourself as a good news source. The media will contact you for stories. You have succeeded in being a great PR practitioner. You are part of the media team, working with them to generate stories for their readership while promoting your creative business.

ACTION PLAN

❑ Practice talking to reporters or editors on the telephone.

❑ Choose a "feel-good day" to conduct media calls.

❑ Write out a phone pitch using the first paragraph of your press release.

❑ Make notes of your discussions with the media in your media list.

❑ Thank the reporter or editor for coverage with an e-mail or phone call.

RECOMMENDED READING

Effective Media Relations: How to Get Results by Michael Bland, Alison Theaker, and David W Wragg

Making News: A Straight-Shooting Guide to Media Relations by David Henderson

Media Relations Handbook by Brad Fitch and Mike McCurry

Beyond the
Press Release

Editorial calendars

Contributed articles

Shoot for the moon. Even if you miss, you'll land among the stars.
Les Brown

EDITORIAL CALENDARS

An Editorial Calendar—EdCal for short—is created by the media to set focus areas for each issue of their publication. Editors generally plan a year in advance what topics they will be covering each issue. For the most part, EdCals are used by PR practitioners and advertisers covering themes in the publication. Create your pitch to the media by knowing what a publication's targeted topics will be for future issues.

Watercolor Artist Magazine

Issue Date	Editorial Focus/Special Issues
02/26/08	How to choose the right workshop for you: take a fun personality quiz to help determine which type of workshop experience is right for you and how to choose among the many opportunities available.
04/22/08	Sell, sell, sell: insiders share tips on how to navigate the art fair circuit, break into small, local galleries and *marketing* and sell your work on the *Internet*.
06/24/08	The ultimate matting and framing *buyers guides*: look at the latest framing innovations, including exciting alternatives to the traditional methods, and how to size and type of support you choose and overall aesthetic vision will affect your opinion.
08/26/08	Top 10 websites for artists: from outstanding product *technology* support to treasuries of inspiring paintings and forums to post your most burning artistic questions.
08/26/08	Get handy advice on how to create your own website.
10/28/08	Ones to watch in the future: 10 watermedia artists whose stars are in the rise.
10/28/08	The best of the best: tour of the best museum and gallery collections of watermedia in the world.
10/28/08	Cool new art products and charming artsy *gifts*.
12/11/07	Enjoy a fun look at history of popular *paints & stains*.
12/11/07	Everything you need to know about watercolor *painting*: learn how to make sense of a paint tube *labeling*, and why different paint qualities create different effects.

LOCATING AN EDITORIAL CALENDAR

You can view an Editorial Calendar at most publications' web sites. Alternatively, you could call the publication directly and have them e-mail an EdCal to you. Make sure they do not e-mail you the Advertising Calendar; ask specifically for the Editorial Calendar.

An EdCal usually includes:

▸ Issue date

▸ Focus of the issue

▸ Distribution - national or regional

▸ Close date - used by advertisers as their deadline for submitting ads and by PR practitioners for submitting editorial content. Note: A media pitch should be conducted far in advance of this date.

You can enhance your PR campaign with an EdCal schedule.

- Compile EdCals of all your prime media outlets.

- Use a highlighter to mark all upcoming stories that fit your art.

- Make sure their editorial close date has not passed.

E-MAILING AN EDCAL PITCH

To: Specific Editor at the magazine

Subject: EdCal inquiry: 4/08 issue on plein pir (Mention the title of the upcoming article – as a "hook")

Dear Mr./Mrs.....,

(In the first paragraph, say why you are writing/calling.) I'm writing to inquire about your upcoming April 2010 issue on plein air as listed in your EdCal and to ask about your interest in including information about my art.

(Convince them that the inclusion of your art is related to their EdCal theme/focus) I have been a plein air artist for the last 20 years. My work has been covered by XX magazine among others, as listed in my Online Newsroom (URL link here) where you can also obtain my Media Kit. I am the winner of XYZ award and have held residencies in (list them). Currently, my work is represented in (fill in) galleries in the US and (fill in) in Europe.

(Tell them you would be happy to provide more information.) Please feel free to contact me via phone (XXX-XXX-XXXX) or e-mail XX@XXX.com if you need additional information.

I look forward to hearing from you in the near future.

(Include full contact info again.) Your name, business name, telephone, e-mail, URL

Use media relations and follow-up techniques as discussed in the previous chapter.

Use your EdCal schedule to pitch future stories. When pitching EdCal stories, mention past media coverage to leverage your pitch.

CONTRIBUTED ARTICLES

Another great way to get your art and name in the public's eye is by contributing an article to a publication.

▸ Focus on your expertise—perhaps you have a new way to mix paints or you paint over digital images. Set yourself up as an expert with a unique angle or experience worth sharing with readers of a given publication.

COMPOSING A CONTRIBUTED ARTICLE

▸ Compile an outline of major points.

▸ Turn these major points into sentences.

▸ Combine sentences into paragraphs of similar focus.

▸ Compile an article of 700-800 words, the standard word count for contributed articles.

▸ Read, re-read, edit and refine.

If you can't compose your thoughts into a well constructed article, ask a writer, friend or colleague to help you.

Once you have completed an article, compile a distribution list using your target media list. Determine the best market for your article. Start with smaller publications, your local paper, your regional arts magazine, your art association newsletter.

As you compile media clippings of contributed articles, conduct further research to place your article in additional, larger markets. Have one or two core articles. Refine or change them to fit different types of media. Your core article will remain the same. Add or delete information to fit the needs of specific publications.

▸ Most publications will provide guidelines for contributed articles.

▸ Most such articles are advice or techniques that can help educate, inform and enlighten the readers.

Use your contributed article to pitch EdCal editors as well. If they can't have your art included in one of their upcoming issues, ask if they would be open to reviewing a contributed article on the theme of the issue. Suggest that it could be used as a sidebar (the boxed information that appears on the margins of main articles).

BYLINES

Bylines usually appear at the end of a contributed article; sometimes they stand out in a box on the side of an article. They include the name of the author as well as a few short notes about the author, noting their expertise (similar to a boiler plate at the end of a press release).

BYLINE EXAMPLES

Once your contributed article is accepted, editors will request your byline.

- XYZ is a plein air artist and the mother of five children. Her work hangs in XYZ Gallery. MyArt, www.myart.com, is based in upstate New York.

- XYZ is a professor of art history at XYZ College. Her works hang in numerous prestigious collections in the US and Europe. She can be reached at xyz@g.com.

ESTABLISHING YOUR EXPERTISE

The more you establish yourself and your expertise, the more you will be sought by the media, both local and national. You may even become a "contributing writer," or better yet, "contributing editor." Your expertise may enlighten readers on a monthly or quarterly basis. You could even advance to write a column of your own!

- Include your contributed articles, even if they don't get published, in your E-newsletter section of your web site.

- E-mail this E-newsletter to the media to establish your expertise and know-how.

- Link your published articles to your Online Newsroom's In the News link.

- Should you get an article published, include a link to the article on your web site.

- Include copies of the article in your clipping book.

- Include unpublished articles in your Educational Materials section of your Online Newsroom.

ACTION PLAN

- ❑ Research EdCals of your target market magazines.
- ❑ Create an article with an appropriate topic.
- ❑ Create a byline.
- ❑ Revise your contributed article for different publications.
- ❑ Use any article placement to leverage placements in other magazines.
- ❑ Post your article, whether placed or not, in your Online Newsroom and in your media kit.
- ❑ Post your contributed article, or portions of it, in your E-Newsletter.

RECOMMENDED READING

Full Frontal PR: Building Buzz about Your Business, Your Product, or You by Richard Laermer

The New PR ToolKit: Strategies for Successful Media Relations by Deirdre Breakenridge and Thomas J DeLoughry

PR on a Budget: Free, Cheap, and Worth the Money Strategies for Getting Noticed by Leonard Saffir

Chapter 8
Creative PR Strategies

Yesterday is but today's memory, and tomorrow is today's dream.
Khalil Gibran

CROSS-MARKETING

Cross-marketing is a joint effort in a promotion campaign. For both parties, it is a win-win situation. Cross-marketing is a great way to increase your art's visibility. Propose a joint event to a few highly visible businesses, organizations or artists in your area to create new customers.

As you progress in the PR world, you will need to think of more and more creative ways to get your name in the media. Continue to brainstorm and write down your ideas; otherwise they seem to vanish into thin air!

- Ask a local frame shop to hang your art. In return, send your buyers to the shop for business.

- Display your art and business cards at your local market. Display the markets information in your studio.

- Ask your local cafe if they would hang your art on their walls and display your business cards. In return, have them cater your Open Studios and pass out their cards.

- Hold a seasonal Open Studio event. Invite a sculptor to share your studio and expenses and invite her customers.

- Sponsor art lessons in your studio, the local school, library, community center.

- Join a group of artists and organize an Earth Day exhibit celebrating the earth with landscape art.

- Commemorate Independence Day, celebrating a cultural heritage; teach, educate, entertain with art.

While holding an exhibit on the Lure of the Seacoast, we invited a local seafood cookbook writer, Jean Kerr (*MYSTIC SEAFOOD COOKBOOK*), to give a talk about her book. The Gallery press release to the newspapers was reinforced by an E-invite from Kerr to her readers and followers. Her presentation included three sample dishes from her cookbook and a reading from her book. The event drew a large crowd who came for the food, the art, and the talk.

VENUES FOR PR

RESIDENCIES

▸ Apply for an Artist-in-Residence program. Utilize print directories and online resources. *Artists Communities: A Directory of Residencies That Offer Time and Space for Creativity* and *Alliance of Artists Communities* (www.artistscommunities. org) are two good resources.

▸ Research regional Arts in Education directories of state arts commissions: *Directory of Minority Arts Organizations* by NEA's Civil Rights Division (available at libraries) is one such source.

▸ Oxbow School of Art and artist's residency has served as a haven for visual artists since 1910. www.ox-bow.org

Once you receive a residency:

▸ Prepare and distribute a press release on your residency to your media list.

▸ Include information on length, location (provide a link to the residency web site), what the selection criteria are, what you will be working on.

▸ Include the information about your residency on your web site's Online Newsroom.

▸ Create a blog while you are at your residency, sharing details of interest with your public and the media.

▸ Offer to become a regular contributor to your local art publication to report on your residency.

Provide post-residency news:

▸ Hold an exhibit, an Open Studio, or a library talk about your residency.

▸ Write and distribute a post-residency press release with images of your new artwork.

▸ Invite the media to interview you about the benefits of an artist's residency.

▸ Ask the organization that provided you the residency to consider you as a spokesperson, maximizing your media and public visibility to a new level.

COLLEGE GALLERIES

If you live in close proximity to a college or university campus, tap into their arts resources. You could also contact your alma mater with a similar proposal.

▸ Use ArtNetwork's mailing list of college galleries (www.artmarketing.com/ml). Pitch your artwork for a possible exhibit.

▸ Offer a lecture or workshop on your method of art to the local art department.

If you are invited to exhibit at a college gallery:

▸ Get a copy of the college's press list if they are willing to share it, and distribute a press release to your media list as well as theirs.

▸ Alternatively, write your own press release and distribute it to the local papers and your own media list.

▸ Be available for media interviews.

▸ Bring a guest book to your art exhibit's opening night and gather e-mail addresses of visitors at your exhibit.

▸ Invite your local buyers to the exhibit.

▸ Offer to "sit" at the gallery once a week to meet visitors and chat with the faculty or staff viewing your exhibit.

▸ Link your web site to the college art gallery's site for the duration of your exhibit.

▸ Post your exhibit press release in your Online Newsroom.

▸ Compile articles published on your exhibit and include them in your media kit and online newsroom.

ART COMPETITIONS

The more awards you win, the more avenues for publicizing your art and your name. Apply to appropriate art competitions. When you win one, use the same channels to publicize your award as you did for your artist's residency. Subscribe to www.artlist.com ($15 per year). This is the leading newsletter for American art competitions.

CORPORATE ART MARKET

Most corporations these days are art-savvy and know the value of enhancing their corporate space with original artwork. Approach your local corporations and offer to educate them about how including original artwork in their space can distinguish their corporation.

▸ Use workbook (www.workbook.com), a company that matches talent and organizations and corporations in need of art. Review and match the corporations to your artwork. Compile a list of potential art buyers, their policies, their needs.

▸ ArtNetwork (www.artmarketing.com) has lists of corporate art consultants and corporations collecting art and photography.

Most public buildings—colleges, municipal offices—are also potential sites for hanging original art. Pitch these organizations.

- Once your artwork is purchased by a corporate client, publicize the sale to your media list.

- Include the press release of your sale in your web site's In the News section.

- Put a blurb in your E-newsletter.

- Ask the corporate client to write and distribute their own press release to their media list for added publicity and exposure.

HEALTH ORGANIZATIONS

Hospitals and health clinics have become strong advocates of art as a means of healing. Psychotherapists highly recommend that arts be used for mental patients, delinquent teens and adults, and chronic patients. Society for the Arts in Health Care (www.thesah.org/template/index.cfm) in Washington, DC, is dedicated to incorporating the arts as an integral component of health care.

Start at your local hospitals, clinics, mental institutions and counseling centers.

- Teach art.

- Meet with hospital officials to inform them about your art.

- Donate an artwork to a hospital and publicize your donation to your list of local media contacts.

PUBLIC ART PROGRAMS

Inquire about your state's Percentage-for-Arts program. This program usually mandates that 0.5% of a public building's estimated construction cost be reserved for commissioned artwork.

Public art programs are a great way to let potential customers see your art, as an artist in your region as well as nationwide. Having your work out in the public is great publicity on its own. You, as chief publicity agent for your art business, will also be able get some great media coverage. Editors know that readers of their magazines and newspapers want to know where their money is being spent, and public art is one of those venues.

- State arts commissions take nominations for some of the projects they handle. Contact your State Arts Commission.

- The General Services Administration (www.gsa.gov) and the National Endowment for the Arts (www.nea.gov) are good organizations to start with. Contact these organizations to find out how you can participate.

Use your press release writing and distribution strategies to publicize all your achievements.

GOING NATIONAL

Once you have successfully established yourself locally and regionally through well publicized gallery exhibits, competitions, art residencies, contributed articles, and more, you will be well prepared to aim for national opportunities.

You've practiced how to write a press release, how to pitch your story to the media, how to come up with creative angles to attract media attention and how to sustain your artistic visibility in the local and regional media. Now you have to enlarge the circle and go national. Your local and regional PR campaign has prepared you for your national launch.

- Research major national arts publications and expand your media list to include these.

- Nationalize a local art story: Commemorating the 9/11 anniversary is a national story, even though the exhibit might be in your town.

- Read *Art Business News* (www.artbusinessnews.com), an excellent national source of news on galleries, museums, publishers, and arts organizations.

- Spend time online viewing web sites of various galleries nationwide.

BROADCAST MEDIA

You will need the same tools (press releases and media kit) for broadcast media—radio, television, cable media outlets—as you do for print media outlets.

MEDIA PITCH

Pitching the broadcast media is not any different than pitching the print media. You can inquire if the radio, TV or cable outlet has specific shows on the arts, or if they conduct interviews and do profiles on artists. If there are such shows, pitch the producers. You can pitch via the phone or e-mail. Conduct the same follow-ups as with print media.

Pitch broadcast media for coverage of your

- Open studio

- Donation of artwork to flood victims, an orphanage, a mental health center, etc.

- Volunteer work with a local charity.

START LOCAL

Start with your local radio, TV or cable outlets. Call and inquire about station managers (radio) or arts and entertainment producers or assignment editors for cable and TV. Once you have the contact information, call or send them an e-mail pitching yourself for an interview. Follow up your phone calls with e-mails and, vice versa, your e-mails with calls. Try to reach a live person and make the pitch. For TV or cable stations, be sure to include images of your artwork in your e-mail. A good story always helps to hook the media. Think, "Why should they be interested in my art over all the other artists' work?"

RADIO INTERVIEWS

- Dress casually and comfortably, as no one will see you.

- Arrive early to take care of any last-minute matters.

- Drink lots of water to clear your throat.

- Ask if you can see a list of questions that will be asked of you.

- While waiting for the taping, rehearse your answers. Articulate them in short sentences.

- Take an extra copy of your media kit to the interview in case they can't locate it or never received it.

- Don't repeat your thoughts; say something clearly and only once.

- Don't laugh loudly into the microphone.

Be sure to get a recording of any interview you do. If it's a TV interview, you can play it at an opening.

Invite the producer or host to your studio.

Radio stations are now taping on-site, where listeners can hear the sounds of a place rather than the quiet of a radio station studio; this is called a "live remote" broadcast.

- Don't interrupt your interviewer.

- Thank the host, while on the air, for giving you the opportunity, both before and after the interview.

- Mention your web site, telephone number and studio address.

- Plug your upcoming exhibits, Open Studio, etc.

TV INTERVIEWS

- Submit digital images of your artwork, which can be shown while you talk.

- Bring in actual pieces of your artwork. Ask if they could place them around you during the interview.

- Dress nicely with bright colors; no checkered shirts, no heavy makeup.

- Follow all the radio interview suggestions above.

- When you are on air, make sure you don't tap your microphone while talking. (It may be on your clothing.)

PUBLICIZE YOUR INTERVIEW

- Include information about your TV or radio interview on your web site and E-newsletter.

- If the radio or TV station posts your interview online, provide a link to the interview on your web site.

- Write and distribute a press release on your radio or TV appearance to your local print media outlets.

CREATING PR GOALS

Now that you have been fully educated to do your own PR, you will need to design your own annual and five-year goals for your PR.

CHART YOUR PR GOALS

Create goals each December for the following year. Update these goals quarterly. At the end of the year, evaluate your achievements. What changes would you make for next year? Make sure your goals are realistic and, at the same time, stretch your boundaries. See *Art Marketing 101* (www.artmarketing.com) for more information on creating goals.

▸ Print your goals in large type and post them on a wall in your studio. View the list on a daily basis. This will redirect you to your goals if you have digressed.

▸ For each main goal, write a list of tasks you need to do to accomplish that goal.

EXAMPLES OF GOALS

▸ Get an art critic to review your work, then start building a relationship with that critic: Take her out for coffee, invite her to your Open Studio, etc.

▸ Become a member of you local Chamber of Commerce and network with other business professionals. Offer to lease your artwork to them.

▸ Get press in the local newspaper. Keep introducing yourself to art editors.

▸ Write an article for an interior design publication about colors, i.e., *A New Approach to Colors*. Establish yourself as an expert color consultant.

▸ Send quarterly communiqué—press releases, exhibit invites, postcard—to your list of art critics, art buyers, etc.

EXAMPLES OF PR GOALS

FOUR MAIN GOALS

1. Exhibit in two local galleries.

2. Get an exhibit reviewed in the media.

3. Publish one of my artworks in a local newspaper or magazine, with a caption that includes, title, medium and price.

4. Reach national media.

STEPS TO REACH GOAL 1

1. Research local galleries, including studying their web sites, visiting their gallery.

2. Include local galleries on my mail list.

3. Contact local galleries to inquire about an exhibit.

4. Hold an Open Studio to introduce galleries to my work.

STEPS TO REACH GOAL 2

1. Write a catchy press release.

2. Decide on a great visual.

3. Send to media and follow up.

4. Ask an art editor to review my exhibit.

STEPS TO REACH GOAL 3

1. Find local publications with art features.

2. Submit my best visuals with captions.

3. Follow up with editor to pitch my art.

4. Ask if they would use my artwork for the cover.

STEPS TO REACH GOAL 4

1. Research appropriate out-of-state galleries to contact.

2. Submit artwork for review to 10 such galleries.

3. Let local and distant media know about my shows.

4. Use the one show I receive to get more shows.

On the next page write four goals and four tasks to help accomplish each of those goals. Photocopy the chart before you fill it out so you can use it in the future.

ANNUAL PR GOALS

FOUR MAIN GOALS

1. _____
2. _____
3. _____
4. _____

STEPS TO REACH GOAL 1

1. _____
2. _____
3. _____
4. _____

STEPS TO REACH GOAL 2

1. _____
2. _____
3. _____
4. _____

STEPS TO REACH GOAL 3

1. _____
2. _____
3. _____
4. _____

STEPS TO REACH GOAL 4

1. _____
2. _____
3. _____
4. _____

PHOTOCOPY THIS PAGE FOR FUTURE USE

CONCLUSION

Use this book as your tool to help increase public and media awareness of your art business and help you think as creatively about the promotion of your art as the creation of your artwork.

Hundreds of thousands of great artists quietly produce amazing artwork in studios around the nation. Those who know how to promote their artwork succeed in selling their creations. This book will help you become one of those artists.

It's your time to come out—reveal yourself and your art—and let the power of PR empower your art business. If you are serious about your art, then start thinking of your art as a business. As with any business, devote time to create and implement a solid, continuous, and flexible PR strategy.

Unleash your PR strategy in your local community, then expand within your region, and then shoot high for national exposure. And remember, just as you continue refining your art, you must refine and revise your PR strategy. To build momentum with your PR campaign, you must implement it on a regular and continual basis. Don't stop promoting your art just because you had a few articles published. Continue pitching, reaching out to the media, to the art reviewers and to the critics. They are your channel to reaching your goals.

❏ Think of three PR hooks.

1. _____

2. _____

3. _____

❏ Note topics on which you are an expert, even if not related to art.

1. _____

2. _____

3. _____

❏ Take the above list, relate it to your art, and write something.

❏ Create a PR plan.

ACTION PLAN

RECOMMENDED READING

Art Marketing 101 by Constance Smith

Appendix

Art publications

Online publications

Resources

Calendar

12-month planning calendar

Publicity planning chart

An artist cannot fail; it is a success to be one.
Charles Horton Cooley

African Arts
Los Angeles, CA 310.825.1218 afriartsedit@international.ucla.edu www.isop.ucla.edu/africa/africanarts 4000 circulation

Afterimage
Rochester, NY 585.442.8676 afterimage@vsw.org www.vsw.org/afterimage 2000 circulation
Features 84 days prior; news 84 days prior

AGSA Newsletter
Zanesville, OH 740.454.1194 www.artglassassociation.com

American Art
Washington, DC 202.275.1500 info@saam.si.edu www.americanart.si.edu

American Art Collector
Scottsdale, AZ 480.425.0806 info@americanartcollector.com www.americanartcollector.com Advertising 60 days prior.

American Art Review
Stratham, NH 603.436.1633 amartrev@aol.com www.amartrev.com 75,000 circulation

American Artist
New York, NY 646.654.5600 mail@myamericanartist.com www.myamericanartist.com 49,000 circulation
Features 60 days prior; news 60 days prior; advertising 60 days prior

American Ceramics
New York, NY 212.661.4397 americanceramics@nyc.rr.com 7500 circulation

American Craft Council Magazine
New York, NY 212.274.0630 council@craftcouncil.org www.craftcouncil.org

American Indian Art Magazine
Scottsdale, AZ 480.994.5445 info@aiamagazine.com www.aiamagazine.com 30,000 circulation
Features 90 days prior; advertising 90 days prior

American Style
Baltimore, MD 410.889.3093 www.americanstyle.com

Art Alliance Bulletin
Philadelphia, PA 215.545.4305 info@philartalliance.org www.philartalliance.org 3000 circulation

Art and Living Magazine
Beverly Hills, CA 310.313.3171 submit@artandliving.com www.artandliving.com 30,000 circulation

Art & Auction
New York, NY edit@artandauction.com www.artandauction.com

Art Bulletin
New York, NY 212.691.1051 publications@collegeart.org www.collegeart.org 30,000 circulation
Advertising 90 days prior

Art Business News
Seven Hills, OH 216.328.8926 www.artbusinessnews.com 28,000 circulation
Features 30 days prior; news 30 days prior; advertising 30 days prior

Art Calendar
Orlando, FL 407.563.7000 khau@artcalendar.com www.artcalendar.com
A business magazine for visual artists

Art in America
New York, NY 212.941.2800 www.artinamericamagazine.com 74,500 circulation
Features 42 days prior; news 42 days prior; advertising 42 days prior

Art Journal
New York, NY 212.691.1051 publications@collegeart.org www.collegeart.org 35,000 circulation

Art New England
Brighton, MA 617.782.3008 editorial@artnewengland.com www.artnewengland.com 30,000 circulation
Features 60 days prior; news 60 days prior; advertising 60 days prior

The Art Newspaper
New York, NY 212.343.0727 contact@theartnewspaper.com www.theartnewspaper.com 22,000 circulation

Art Now Gallery Guide
Clinton, NJ 908.638.5255 artnow@galleryguide.com www.galleryguide.com

Art of the West
Minnetonka, MS 800.937.9194 aotw@aotw.com www.aotw.com

Art on Paper
New York, NY 212.675.1968 edit@dartepub.com www.artonpaper.com 18,000 circulation
Features 90 days prior; news 40 days prior; advertising 30 days prior

Art Papers
Atlanta, GA 404.588.1837 info@artpapers.org www.artpapers.org 162,000 circulation
Features 112 days prior; news 112 days prior; advertising 42 days prior

Art Scene
Thousand Oaks, CA 213.482.4724 artscene@artscenecal.com artscenecal.com 15,000 circulation

Art Showcase Magazine
Ann Arbor, MI 734.340.5900 info@artshowcasemagazine.com www.artshowcasemagazine.com 25,000 circulation
Features 90 days prior; advertising 30 days prior

Art Times
Saugerties, NY 845.246.6944 info@arttimesjournal.com www.arttimesjournal.com 28,000 circulation
Advertising 45 days prior

Art-Talk
Scottsdale, AZ 480.948.1799 admin@art-talk.net www.art-talk.net 40,000 circulation

Art-to-Art Palette
Ohio City, OH art-to-art@bright.net arttoartpalette.com

Artforum
New York, NY 212.475.4000 generalinfo@artforum.com www.artforum.com 31,000 circulation
Features 90 days prior; news 90 days prior; advertising 60 days prior

Artist Interviews Magazine
Los Angeles, CA 310.492.5414 media@artistinterviews.com www.artistinterviews.com 40,000 circulation
Features 50 days prior; advertising 50 days prior

The Artist's Magazine
Cincinnati, OH 513.531.2690 tamedit@fwpubs.com www.artistsmagazine.com 157,000 circulation
Features 150 days prior; news 120 days prior; advertising 90 days prior

ARTnews
New York, NY 212.398.1690 info@artnews.com www.artnews.com 84,000 circulation
Features 35 days prior; news 35 days prior; advertising 35 days prior

ARTnewsletter
New York, NY 212.398.1690 www.artnewsonline.co

artUS
Los Angeles, CA 213.625.2010 artus@artext.org www.artext.org 40,000 circulation
Features 90 days prior; advertising 60 days prior

Artweek
Palo Alto, CA 800.733.2916 editorial@artweek.com www.artweek.com 12,000 circulation

Blind Spot
New York, NY 212.633.1317 www.blindspot.com
Art photography

Ceramics Monthly
Westerville, OH 866.721.3322 editorial@ceramicsmonthly.org www.ceramicsmonthly.org 39,000 circulation
Features 60 days prior; advertising 72 days prior

Chicago Artists' News
Chicago, IL 312.781.0040 info@caconline.org www.caconline.org 2700 circulation
Features 60 days prior; news 60 days prior; advertising 55 days prior

Chicago Gallery News
Chicago, IL 312.649.0064 cgnchicago@aol.com www.chicagogallerynews.com 18,000 circulation
News 60 days prior; advertising 60 days prior

China Painter
Oklahoma City, OK 405.521.1234 wocporg@theshop.net www.theshop.net/wocporg 7000 circulation

Coagula Art Journal
Los Angeles, CA 323.223.6089 coagulaeditor@hotmail.com www.coagula.com 12,500 circulation
Features 21 days prior; news 21 days prior; advertising 14 days prior

Crafts News
Silver Spring, MD 301.587.4700 craftscenter@chfinternational.org www.craftscenter.org 300 circulation

Decor
Maryland Heights, MO 314.824.5500 kstefek@sbmediallc.com www.decormagazine.com

Fiberarts
Loveland, CO 970.669.7672 info@fiberarts.com www.fiberarts.com 17,000 circulation
Features 180 days prior; news 180 days prior; advertising 90 days prior

Fine Art Connoisseur
West Palm Beach, FL 561.655.8778 editorial@fineartconnoisseur.com www.fineartconnoisseur.com 22,000 circulation
Advertising 60 days prior

Fired Arts & Crafts
Iola, WI 715.445.5000 editor@firedartsandcrafts.com www.jonespublishing.com 7500 circulation
Features 56 days prior; news 56 days prior; advertising 28 days prior

Folk Art Magazine
New York, NY 212.977.7170 www.folkartmuseum.org 10,000 circulation

Folk Art Messenger
Richmond, VA 804.285.4532 fasa@folkart.org www.folkart.org 1200 circulation
Features 90 days prior; news 60 days prior

Glass Focus
Morton Grove, IL 847.967.8433 glassfocus@comcast.net www.glassfocus.net 2000 circulation
Advertising 30 days prior

Glass on Metal
Bellevue, KY 859.291.3800 info@glass-on-metal.com www.glass-on-metal.com 1000 circulation

Glass Patterns Quarterly
Westport, KY 502.222.5631 info@glasspatterns.com www.glasspatterns.com 35,000 circulation
Features 180 days prior; news 60 days prior; advertising 60 days prior

Glass: The Urbanglass Art Quarterly
Brooklyn, NY 718.625.3685 info@urbanglass.org www.urbanglass.org 8000 circulation
Features 90 days prior; news 90 days prior

Horses in Art
Jamul, CA 619.447.2749 www.horsesinart.com 7500 circulation

Images
Riverside, CA 951.697.4750 custserv@theworldart.com www.theworldart.com 10,000 circulation

InformArt
Easton, CT 203.268.5552 informart@mac.com www.informartmag.com 40,000 circulation
Features 60 days prior; news 60 days prior; advertising 30 days prior

Inside Arts
Washington, DC 202.833.2787 editor@artspresenters.org www.artspresenters.org 20,000 circulation
Advertising 40 days prior

Journal of the Print World
Meredith, NH 603.279.6479 jprintworld@metrocast.net www.journaloftheprintworld.com 10,000 circulation

Limited Edition
Ann Arbor, MI 734.662.3382 guild@michiganguild.org www.michiganguild.org 1000 circulation

Modernism Magazine
Lambertville. NJ 609.397.4104 info@modernismmagazine.com www.modernismmagazine.com 30,000 circulation
Features 75 days prior; news 75 days prior; advertising 75 days prior

National Association of Women Artists Newsletter
New York, NY 212.675.1616 office@nawanet.org www.nawanet.org 1000 circulation

NY Arts Magazine
New York, NY 212.274.8993 info@nyartsmagazine.com www.nyartsmagazine.com 10,000 circulation

The Pastel Journal
Cincinnati, OH 513.531.2690 pjedit@fwpubs.com www.pasteljournal.com 23,000 circulation
Features 14 days prior; news 7 days prior; advertising 30 days prior

Profitable Glass Quarterly
Westport, KY 502.222.5631 info@profitableglass.com www.profitableglass.com 5300 circulation
Features 90 days prior; news 90 days prior; advertising 45 days prior

Public Art Review
Saint Paul, MN 651.641.1128 info@publicartreview.org www.publicartreview.org 5000 circulation

Quilting Arts Magazine
Stowe, MA 866.698.6989 editorial@quiltingarts.com www.quiltingarts.com

Sculptural Pursuit
Littleton, CO 303.738.9892 editorsp@sculpturalpursuit.com www.sculpturalpursuit.com 4000
Advertising 30 days prior

Sculpture Magazine
Washington, DC 202.234.0555 isc@sculpture.org www.sculpture.org 25,000 circulation
Features 60 days prior; news 60 days prior; advertising 60 days prior

Sculpture Review
New York, NY 212.529.1763 www.sculpturereview.com

Southwest Art
Boulder, CO 303.449.4599 southwestart@southwestart.com www.southwestart.com 55,800 circulation
Features 90 days prior; news 90 days prior; advertising 90 days prior

Southwest Colorado Arts Perspective
Mancos, CO 970.739.3200 www.artsperspective.com 10,000 circulation
Features 60 days prior; advertising 20 days prior

Stained Glass
Raytown, MO 816.737.2090 quarterly@sgaaonline.com www.stainedglass.org 4000 circulation
Features 90 days prior; news 90 days prior; advertising 90 days prior

Sunshine Artist Magazine
Orlando, FL 407.648.7479 editor@sunshineartist.com www.sunshineartist.com 14,000 circulation
Advertising 85 days prior

Surface Design Journal
Englewood, NJ 201.568.1084 surfacedesign@mail.com www.surfacedesign.org 5800 circulation
Features 180 days prior; news 120 days prior; advertising 120 days prior

Watercolor Artist
Cincinnati, OH 513.531.2690 wcmedit@fwpubs.com www.watercolormagic.com 53,000 circulation
Features 120 days prior; advertising 30 days prior

Wildlife Art
Ramona, CA 760.788.9453 publisher@wildlifeartmag.com www.wildlifeartmag.com 32,500 circulation
Features 120 days prior; news 120 days prior; advertising 63 days prior

Women in the Arts
Washington, DC 202.783.7981 www.nmwa.org 50,000 circulation
Features 90 days prior; news 90 days prior; advertising 90 days prior

X-TRA Contemporary Art Quarterly
Los Angeles, CA 323.982.0279 editors@x-traonline.org www.x-traonline.org

Animation Artist
Laguna Niguel, CA 949.251.0199 news@digitalmedianet.com www.animationartist.com

Animation Magazine
Westlake Village, CA 818.991.2884 edit@animationmagazine.net www.animationmagazine.net

Animation World Magazine
Hollywood, CA 323.606.4200 editor@awn.com www.awn.com

Art Knowledge News
Miami, FL 305.433.8413 editor@artknowledgenews.com www.artknowledgenews.com

BlackTalentNews.com
Beverly Hills, CA 310.203.1336 info@blacktalentnews.com www.blacktalentnews.com

The Blueprint
New York, NY 212.665.8873 info@nyblueprint.com www.nyblueprint.com

Boxoffice Online
West Hollywood, CA 310.858.4500 editorial@boxoffice.com www.boxoffice.com

bright lights film journal
Portland, OR 503.228.2946 brightlightsfilm@yahoo.com www.brightlightsfilm.com

calendarlive.com
Los Angeles, CA 213.237.5000 feedback@latimes.com www.calendarlive.com

Celebrity Datebook
New York, NY 212.757.7979 www.celebrityservice.com

Chicago Scene Magazine
Chicago, IL 312.587.3474 email@chicago-scene.com www.chicago-scene.com/scene.htm

cinemATL Magazine
Decatur, GA 706.692.2110 info@cinematl.com www.cinematl.com

Club Freetime
New York, NY 212.545.8900 events@clubfreetime.com www.clubfreetime.com

ContentAgenda
Los Angeles, CA 323.857.6600 www.contentagenda.com

Digital Cinema Report
Nyack, NY 845.353.6837 publisher@digitalcinemareport.com www.digitalcinemareport.com

digital cinematography
New York, NY 212.378.0400 news@creativeplanet.com www.dcinematography.com

Film & Video
New York, NY 212.621.4900 www.filmandvideomagazine.com

Film Journal International
New York, NY 646.654.7680 www.filmjournal.com

Filmmaker
New York, NY 212.563.0211 www.filmmakermagazine.com

Films in Review
New York, NY 212.873.6626 www.filmsinreview.com

FilmStew.com
Santa Clarita, CA 310.796.9245 info@filmstew-inc.com www.filmstew.com

Go & Do Michigan
Southgate, MI 734.246.0800 editor@goanddomichigan.com www.goanddomichigan.com

Good Times
Jericho, NY 516.827.4145 gtmag@optonline.net www.goodtimesmag.com

Illinois Entertainer
Chicago, IL 312.930.9333 ed@illinoisentertainer.com www.illinoisentertainer.com

indieWIRE
Brooklyn, NY 212.675.3908 office@indiewire.com www.indiewire.com

Ink 19
Melbourne, FL editor@ink19.com www.ink19.com

The InterMixx Webzine
Norwalk, CT 203.483.1798 www.intermixx.com

Live Design
New York, NY 866.505.7173 ldcs@pbsub.com www.livedesignonline.com

LouisvilleHotBytes.com
Louisville, KY 502.899.1100 www.louisvillehotbytes.com

Make-Up Artist Magazine
Vancouver, WA 360.882.3488 www.makeupmag.com

MicroFilmmaker Magazine
Lexington, KY 859.229.8655 www.microfilmmaker.com

MuseumSpot.com
Evanston, IL 847.866.1830 editors@museumspot.com www.museumspot.com

Orlando Leisure
Maitland, FL 407.647.5557 press@orlandoleisure.com www.orlandoleisure.com

OrlandoCityBeat.com
Orlando, FL 407.420.5000 feedback@orlandocitybeat.com www.orlandocitybeat.com

Out & About
Wilmington, DE 302.655.6483 contact@out-and-about.com www.out-and-about.com

Portland Picks
Portland, OR 503.67.52580 picks@portlandpicks.com www.portlandpicks.com

Internet Magazine
CA 818.291.1100 www.postmagazine.com

Internet Magazine
NY 212.767.6000 premletters@hfmus.com www.premiere.com

Real Detroit Weekly
Ferndale, MI 248.591.7325 letters@realdetroitweekly.com www.realdetroitweekly.com

SF Station
San Francisco, CA 415.552.5588 editorial@sfstation.com www.sfstation.com

ShowBIZ Data
Los Angeles, CA 323.933.1344 info@showbizdata.com www.showbizdata.com

SohoTampa.com
Tampa, FL 813.283.0760 www.sohotampa.com

Talent in Motion
New York, NY 212.354.7189 talentinmotion@mindspring.com www.timmag.com

TampaGold.com
Tampa, FL 813.283.0760 www.tampagold.com

theGAZZ.com
Charleston, WV 304.348.5100 gazz@wvgazette.com www.thegazz.com

This Week in New York
New York, NY 212.683.9353 admin@twi-ny.com www.twi-ny.com

www.mediafinder.com
 Provides newspapers, magazines and blogs by state as well as daily, weekly, monthly circulations

www.newslink.org
 Provides 70,000 listings of US and Canadian newspapers, magazines, newsletters, directories, and trade publications

www.gebbieinc.com/tvintro.htm
 Television station listings you can select by state. Provides direct links to the stations' web sites, where you can find contact information.

www.windowsmedia.com/radiotuner/MyRadio.asp
 Radio station listings

Publicity Hound's Tips of the Week
 www.publicityhound.com
 Joan Stewart provides a free E-zine on how to increase your publicity. She also has a handy checklist, which can be downloaded for free: *89 Reasons to Send News Releases.*

The Art of Self Promotion
 PO Box 23, Hoboken, NJ 07030 201.653.0783 www.art-of-self-promotion.com
 133 Tips to Promote Yourself and Your Business by Ilise Benun is a 20-page, information-packed guide with easy-to-put-into-action tips.

Look in your library at the most current issues of these publications for media leads:
 Artist's Market
 Gale Directory of Publications
 International Yearbook
 Media Guide
 Bacon's Publicity Checker
 Standard Periodical Directory
 Editor and Publisher International Yearbook
 Working Press of the Nation
 Newsletters in Print
 Oxbridge Directory of Newsletters
 American Art Directory

E-zines
 www.artezine.com
 www.worldofwatercolor.com
 www.zeroland.co.nz/art_ezines.html
 www.zonezero.com

12-MONTH PLANNING CALENDAR

JANUARY	FEBRUARY	MARCH

APRIL	MAY	JUNE

JULY	AUGUST	SEPTEMBER

OCTOBER	NOVEMBER	DECEMBER

PUBLICITY PLANNING CHART

	IDEA/EVENT	MATERIALS NEEDED	DEADLINES
Daily newspapers			
Weekly newspapers			
Local publications			
Local magazines			
Radio			
TV			

NOTES

ART WORLD MAILING LISTS

Artists (47,000 names) .$100 per 1000

Architects (640 names) . $60

Art Councils (640 names) . $60

Art Museums (900 names) . $75

Art Museum Store Buyers (490 names) . $55

Art Organizations (1700 names) . $99

Art Publications (670 names) . $65

Art Publishers (1100 names) . $85

Book Publishers (300 names) . $50

Calendar Publishers (100 names) . $50

College Art Departments (2400 names) . $99

Corporate Art Consultants (200 names) . $55

Corporations Collecting Art (475 names) . $60

Corporations Collecting Photography (125 names) $50

Galleries (5500 nationwide names) . $355

Galleries Carrying Photography (320 names) . $50

Galleries/New York (750) (more city/state selections online) $75

Greeting Card Publishers (600 names) . $65

Interior Designers (600 names) . $55

Licensing Contacts (180 names) . $50

Reps, Consultants, Dealers, Brokers (1500 names) $75

All lists can be rented for onetime use and may not be copied, duplicated or reproduced in any form. Lists have been seeded to detect unauthorized usage. Reorder of same lists within a 12-month period qualifies for 25% discount. Lists cannot be returned or exchanged.

Formats/Coding
All domestic names are provided in zip code sequence on three-up pressure-sensitive—peel-and-stick—labels (these are not e-mail lists).

Shipping
Please allow one week for processing your order once your payment has been received. Lists are then sent Priority Mail and take an additional 2-4 days to arrive. Orders sent without shipping costs will be delayed. Shipping is $5.50 per order.

Guarantee
Each list is guaranteed 95% deliverable. We will refund 41¢ per piece for undeliverable mail in excess of 5% if returned to us within 90 days of order. We mail to each company/person on our list a minimum of once per year. Our business thrives on responses to our mailings, so we keep our lists as up-to-date and clean as we possibly can.

ArtNetwork, PO Box 1360, Nevada City, CA 95959-1360
530·470·0862 www.artmarketing.com

BUSINESS BOOKS FOR ARTISTS

Art Marketing 101, A Handbook for the Fine Artist

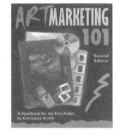

This comprehensive 21-chapter volume covers everything an artist needs to know to market his work successfully. Artists will learn how to avoid pitfalls, as well as identify personal roadblocks that have hindered their success in the art world.

Preparing a portfolio * Pricing work * Alternative venues for selling artwork
Taking care of legal matters * Developing a marketing plan
Publicity * Succeeding without a rep * Accounting * Secrets of successful artists

Licensing Art 101: Selling Reproduction Rights for Profit

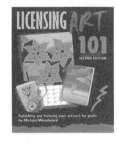

Expose your artwork to potential clients in the art publishing and licensing industry. You will learn how to deal with this vast marketplace and how to increase your income by licensing your art. Contains names, addresses, telephone numbers and web sites of licensing professionals and agents.

Negotiating fees * How to approach various markets * Targeting your presentation
Trade shows * Licensing agents * Protecting your rights

Selling Art 101: The Art of Creative Selling

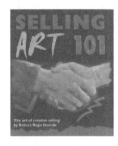

This book teaches artists, art representatives and gallery sales personnel powerful and effective selling methods. It provides easy-to-use techniques that will save years of frustration. The information in this book, combined with the right attitude, will take sales to new heights.

Closing secrets * Getting referrals * Telephone techniques * Prospecting clients
14 power words * Studio selling * How to use emotions * Finding and keeping clients
Developing rapport with clients * Goal setting * Overcoming objections

Internet 101: With a Special Guide to Selling Art on eBay

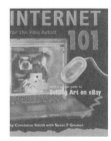

This user-friendly guide explains exhibiting, promoting and selling artwork on-line. It also teaches in detail how one artist made $30,000 selling her art on eBay.

Internet lingo * E-mail communication shortcuts * Doing business via e-mail * Meta tags
Creative research on the web * Acquiring a URL * Designing your art site
Basic promotional techniques for attracting clients to your site * Pay-per-click advertising
Search engines * Tracking visitors * Reference sources

Art Office: 80+ Forms, Charts, Legal Documents

This book contains 80+ forms that provide artists with a wide selection of charts, sample letters, legal documents and business plans . . . all for photocopying. Organize your office's administrative and planning functions. Reduce routine paperwork and increase time for your art creation.

12-month planning calendar * Sales agreement * Form VA * Model release
Phone-zone sheet * Checklist for a juried show * Slide reference sheet
Bill of sale * Competition record * Customer-client record * Pricing worksheet

ArtNetwork, PO Box 1360, Nevada City, CA 95959-1360
530·470·0862 www.artmarketing.com

WWW.ARTMARKETING.COM